The Big Book of SMALL TATTOOS

Vol. 1

400 *original tattoos*
for women and men

TattooTribes
2019

TattooTribes Ed.

© 2019 Roberto Gemori.

ISBN-13: 978-8894205688

ISBN-10: 88-942056-8-1

2021, 2ND EDITION

All original images by TattooTribes except for the Seed of Life

Chapters index

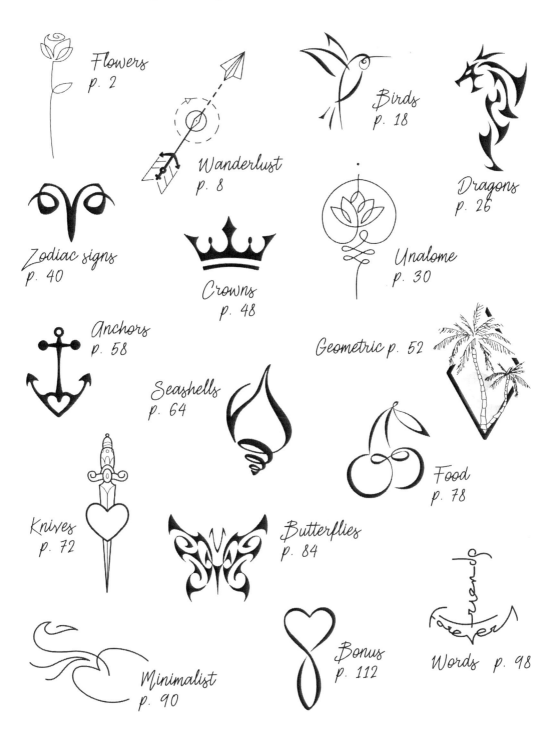

GIFT VOUCHER

Want to download the PDF version
to read it anywhere, any time?
It comes **FREE** with this copy of your book!

You can download it from ➝

www.tattootribes.com/free/smalltattoos1-pdf.php

Introduction

Whether you are approaching tattoos for the first time and want to start small, or you're a longtime fan and only have just that tiny little spot left, you will appreciate this book and its philosophy: **small and meaningful**.

TattooTribes has worked for more than twenty years now to create beautiful tattoos that are meaningful too, and this is no exception: *The Big Book of Small Tattoos, Vol.1* features over 400 small tattoo designs for women and men purposefully created to be one-of-a-kind and with variants showing how, with a few simple changes, each of them can become more personal and unique.

This is not a collection of tattoos from the web— they are all original designs that you can't find anywhere else.

So . . . what will your next tattoo be?

Flowers

There is an infinite variety of flowers and plants, each with its own shape, color, and personality: flowers, like people, can be delicate or strong, plain or colorful.
What is your flower?

Rose

Roses are beautiful and
scented flowers that
seem delicate and
fragile, but which have
thorns to defend
themselves.
That's why they
represent beauty and
strength.
They also symbolize
love and romance.

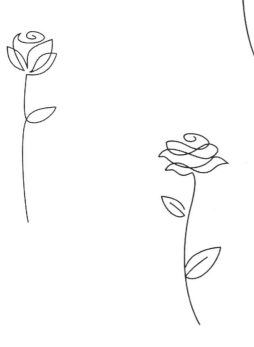

Daisy

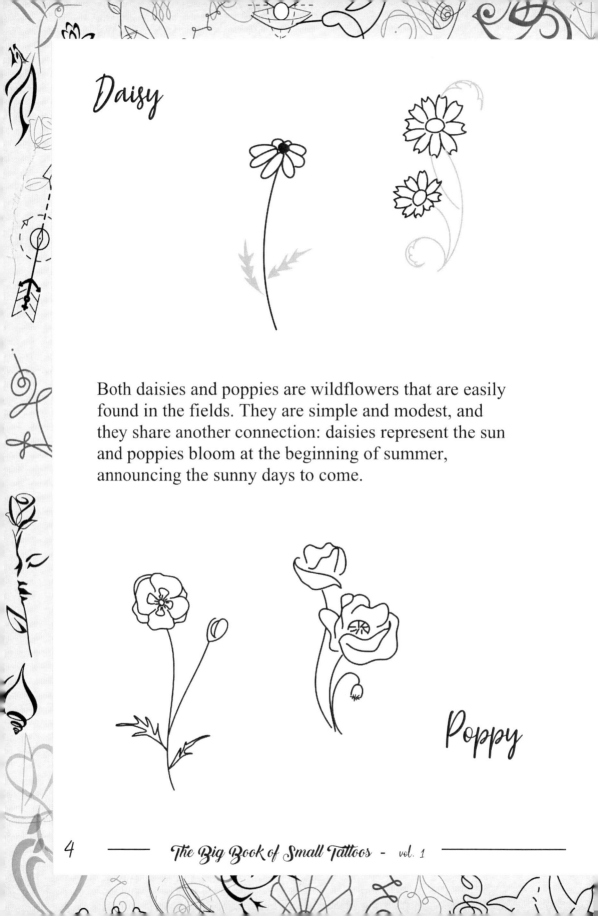

Both daisies and poppies are wildflowers that are easily found in the fields. They are simple and modest, and they share another connection: daisies represent the sun and poppies bloom at the beginning of summer, announcing the sunny days to come.

Poppy

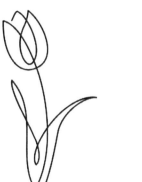

Tulip

Like roses, tulips have a varied symbolism depending on their color, from joy (yellow) to forgiveness (white), and royalty (purple), but their main meaning is perfect love, elegance, and grace.

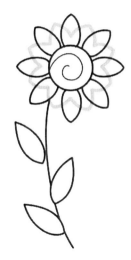

Sunflower

Sunflowers turn to follow the sun. Their symbolism is related to adoration, loyalty, and longevity, but they are also a symbol for joy.

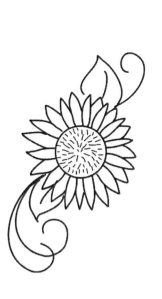

Orchid

Orchids are associated with sexuality and fertility.
They are a symbol of passion and nobility.

Frangipani

Frangipanis are fragrant flowers that remind us of tropical islands.
They are a symbol for beauty, femininity, and grace, while also being related to new beginnings.

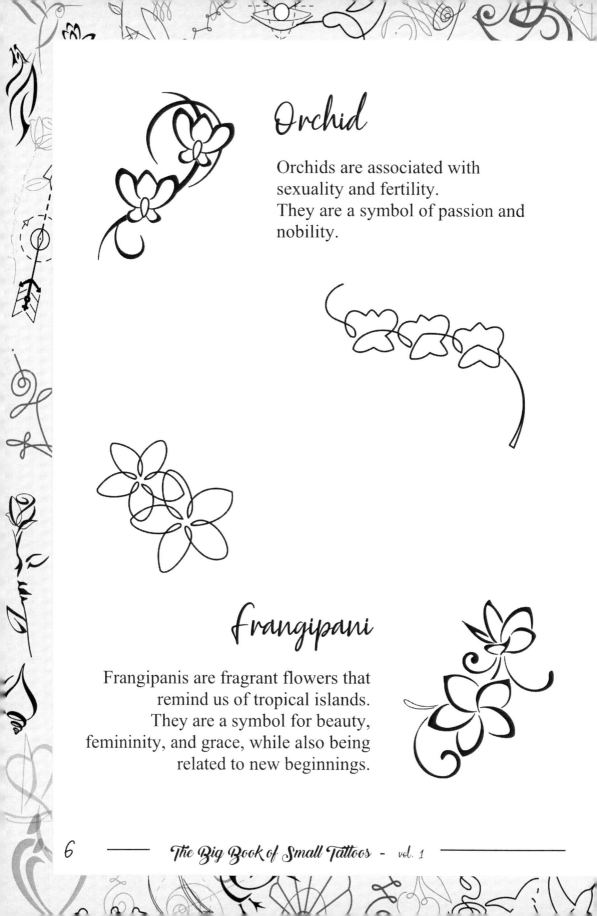

Floral patterns are a common way to add a bit of elegance to a tattoo. Their delicate simplicity makes them perfect for bracelets around wrists and ankles.

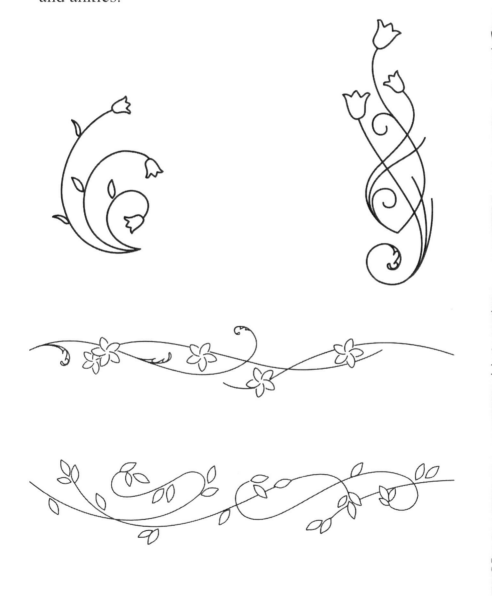

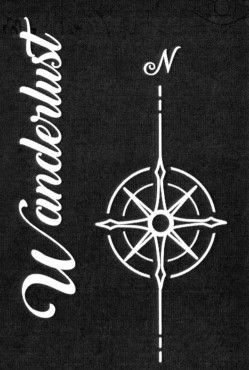

Wanderlust

N

noun: strong longing for or impulse toward wandering, experiencing the unknown, confronting unforeseen challenges, and getting to know unfamiliar cultures, ways of life, and behaviors.

"For my part, I travel not to go anywhere, but to go. I travel for travel's sake. The great affair is to move."

Robert Louis Stevenson

fly away

The unalome is a Buddhist symbol representing the journey to reach enlightenment, first uncertain and wandering, and then straight and firm.

One path to enlightenment?
Traveling!

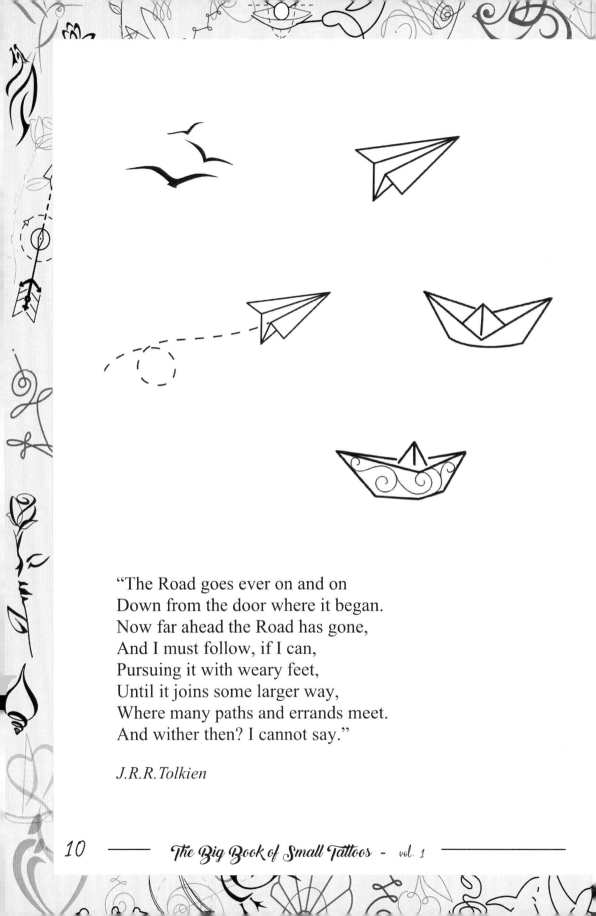

"The Road goes ever on and on
Down from the door where it began.
Now far ahead the Road has gone,
And I must follow, if I can,
Pursuing it with weary feet,
Until it joins some larger way,
Where many paths and errands meet.
And wither then? I cannot say."

J.R.R.Tolkien

sail

"I am the master
of my fate,
I am the captain
of my soul."

William Ernest Henley

A hearts that beats is a heart that feels.
A heartbeat line can be an elegant ankle or wrist band symbolizing this passion, be it for a specific town or for more than one. It's as easy as adding your own cityscape or landmarks!

You can also include words within the heartbeat, such as *Wanderlust* or *Voyage*, for example.

Voyage

Arrows represent
direction, the path
to what matters to us.

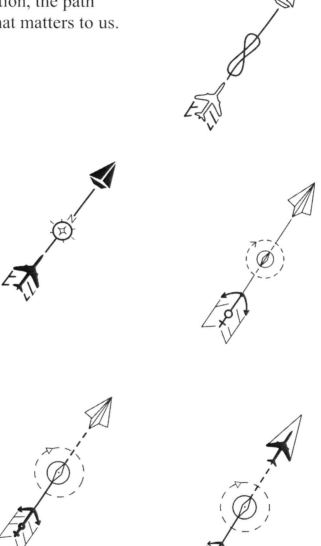

"Our battered suitcases were piled on the sidewalk again; we had longer ways to go. But no matter, the road is life."

Jack Kerouac

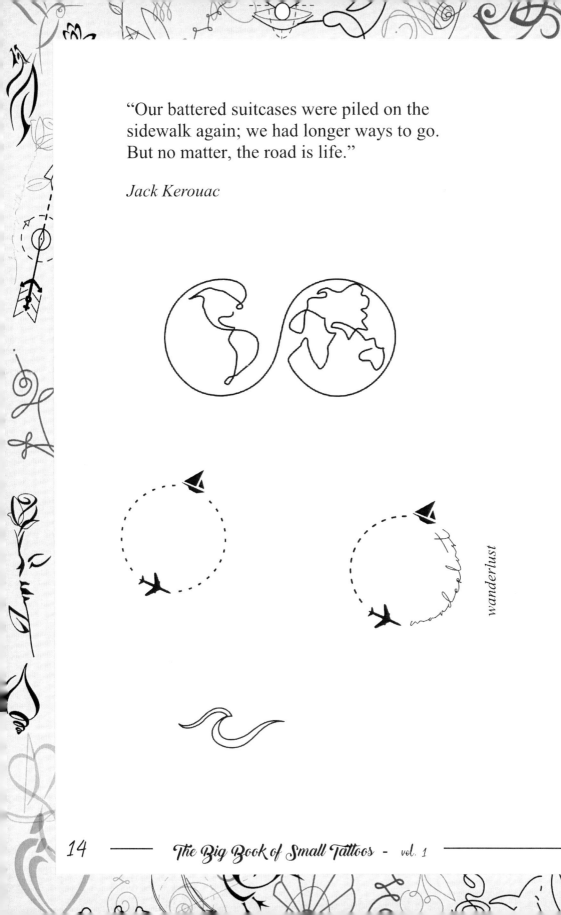

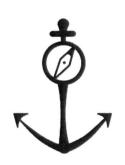

The anchor and the compass represent stability, direction, having a path to follow in life, or a place to return to.

Even a simple map pin can be meaningful when tattooed on the heart.

The wind symbolizes roaming, exploring, letting yourself be carried away without a planned destination.

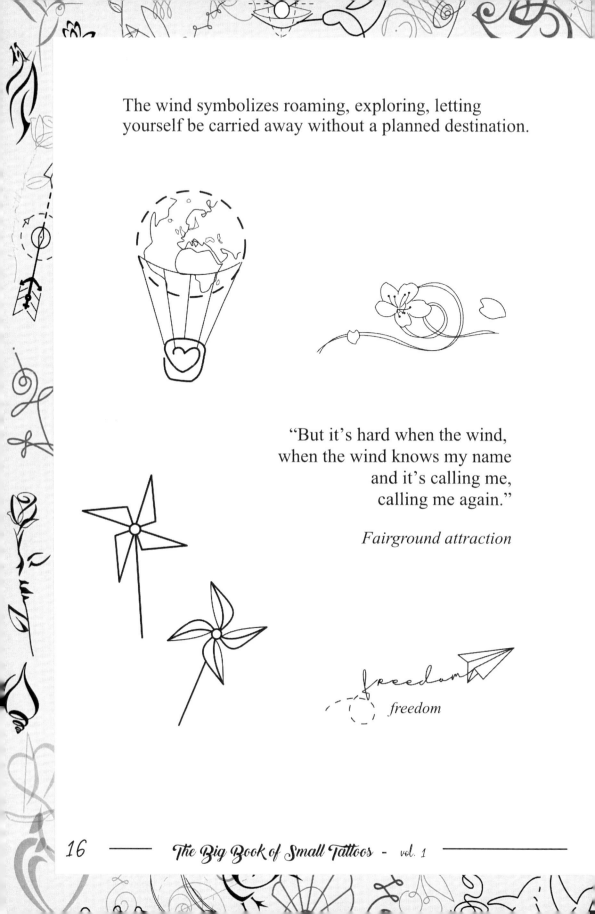

"But it's hard when the wind,
when the wind knows my name
and it's calling me,
calling me again."

Fairground attraction

freedom

Wanderlust

Palm trees represent exotic destinations
and the "island vibe", that laid back
attitude that makes every place home
and every friend family.

Morse code makes the perfect base for anklets or
bracelets spelling meaningful words.
Letters can be separated by hanging elements related to
the word. The below example spells "VOYAGE".

Birds

Birds always fascinated humanity.
Their ability to rise and fly over human struggles and limits has been associated with freedom, wisdom, and higher perspective. They are also often considered messengers from higher powers.

Hummingbird

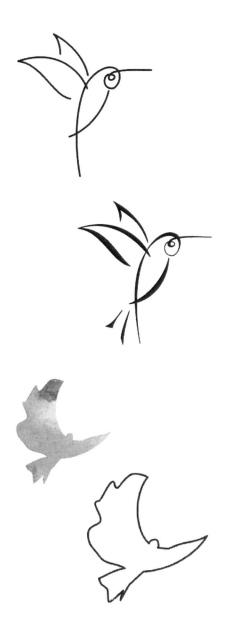

Sipping nectar from flowers, hummingbirds symbolize taking the best from life, *carpe diem*.

A few minor changes like joining some lines or making them bolder, can turn each design into a unique one:

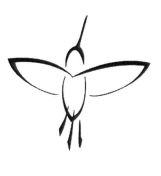

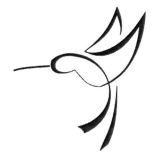

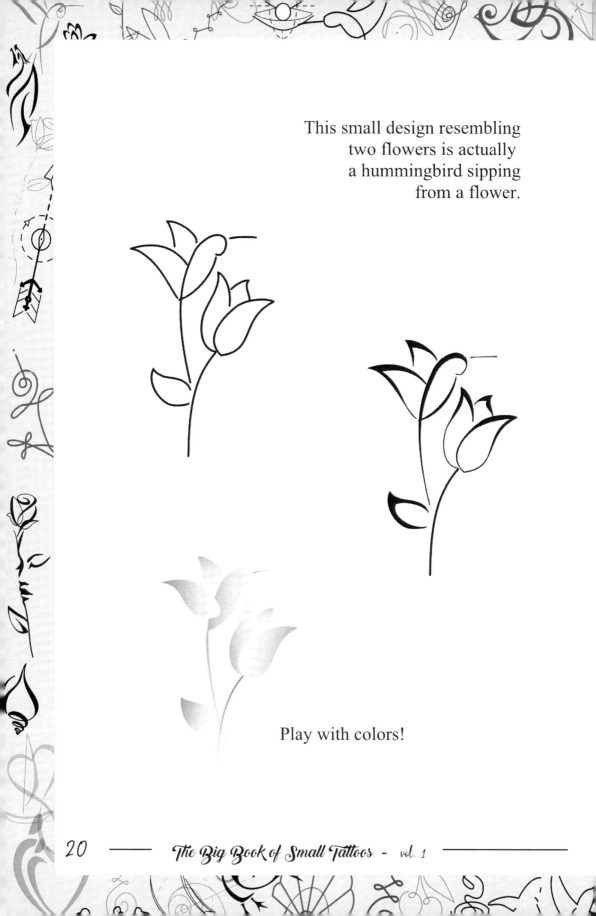

This small design resembling
two flowers is actually
a hummingbird sipping
from a flower.

Play with colors!

Swallow

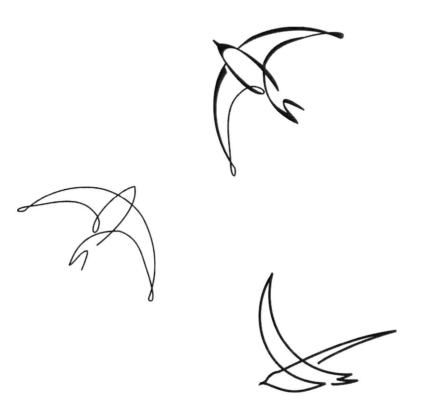

Swallows are
tireless travelers,
who always return every year
to their old nest.
On this account, they symbolize
freedom, fidelity, and safe return.

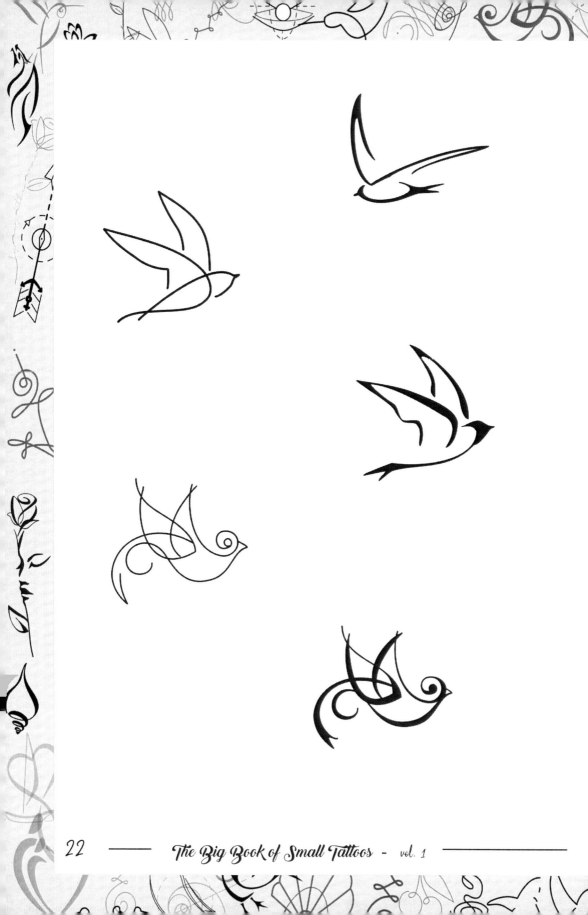

Owl

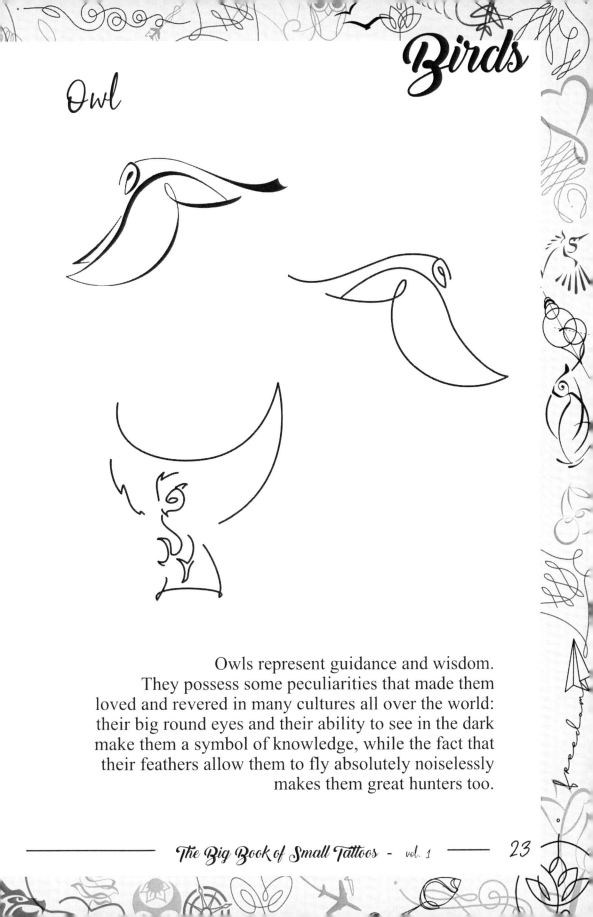

Owls represent guidance and wisdom.
They possess some peculiarities that made them
loved and revered in many cultures all over the world:
their big round eyes and their ability to see in the dark
make them a symbol of knowledge, while the fact that
their feathers allow them to fly absolutely noiselessly
makes them great hunters too.

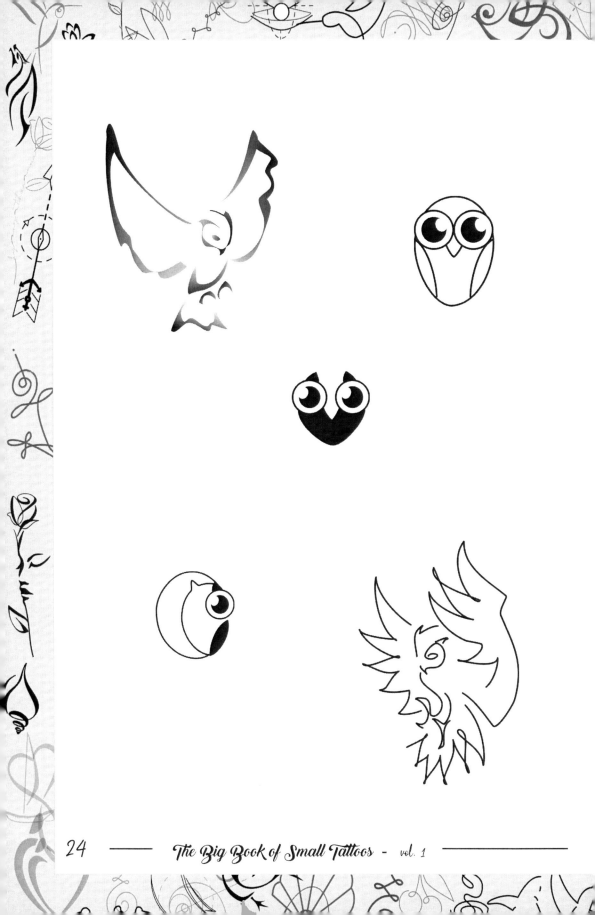

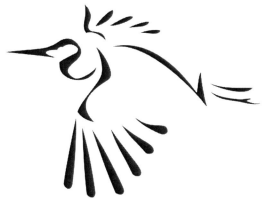

Heron

Herons are majestic birds, and they are often associated with awareness and leadership. They also symbolize resourcefulness and tranquility.

Kiwi

The kiwi bird is a symbol of generosity.

Dragons

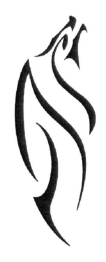

Dragons appear in myths all around the world. While in Western cultures they have mostly a negative connotation, in Eastern traditions dragons are considered benevolent creatures possessing magical powers.
They symbolize wisdom, longevity, sexuality and fertility, regeneration, prosperity, power, and good fortune.

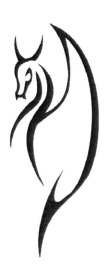

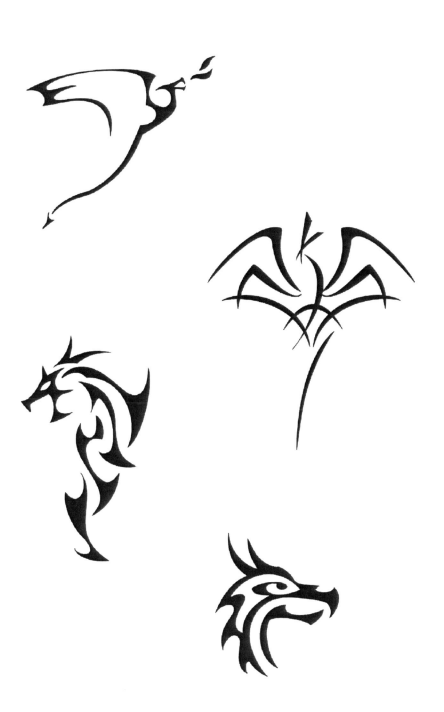

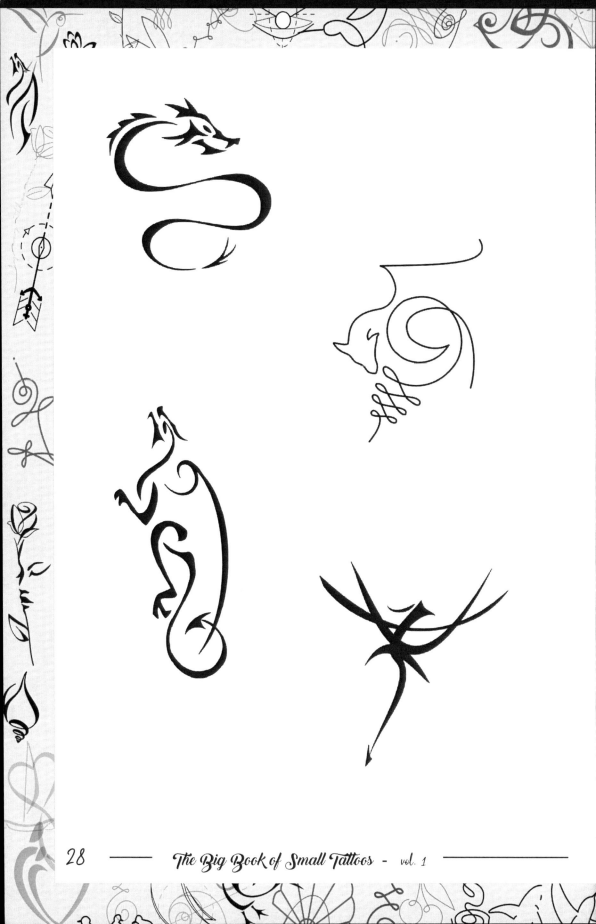

European and Japanese dragons have similar physical characteristics, but opposite significance: while the former were associated with destruction (they breathed fire), the latter were water deities who brought life and regeneration to the land. They were highly revered for their powers and were the symbols of the emperor.

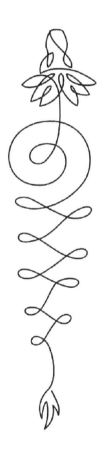

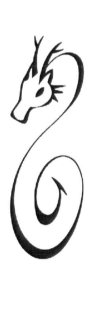

Unalome

The unalome represents the path to perfection. It is typically composed by a single line tracing a path that starts swirling and then smooths out until it becomes straight, ending with a dot representing enlightenment. Why not use the swirls to create different designs that add your meaning to it? What is on your way to perfection?

Snake

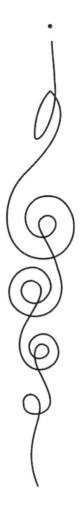

Snakes can renew their skin, and they are a symbol of transformation, fertility, and appeal.

Scorpion

The scorpion is a symbol of
passionate love: its sting causes
hot flashes, accelerated heart rate,
shortened breath, and feverish
eyes. Because of its sting, it is
also a masculine symbol.

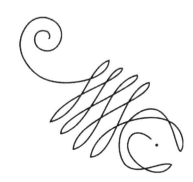

Lotus

Lotus flowers grow out of muddy waters and bloom
immaculately above them, untouched by dirt.
They therefore symbolize perfection
and rising above adversities.

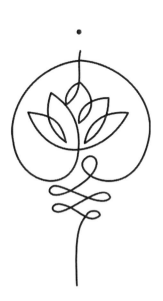

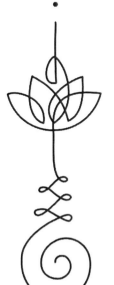

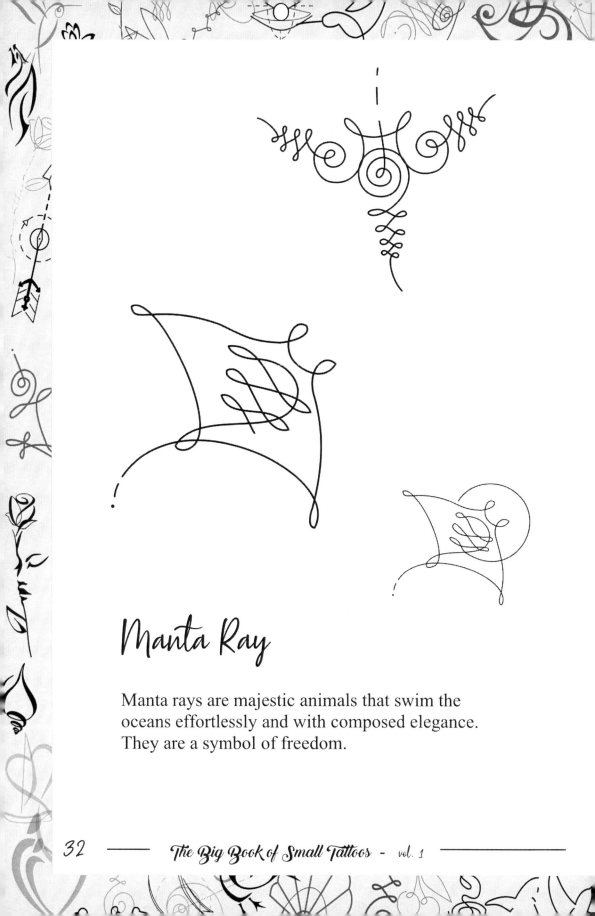

Manta Ray

Manta rays are majestic animals that swim the oceans effortlessly and with composed elegance. They are a symbol of freedom.

Dolphin

Dolphins are social animals who love spending time together and even enjoy playing in the waves. They symbolize friendship and playfulness.

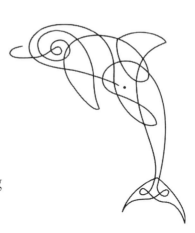

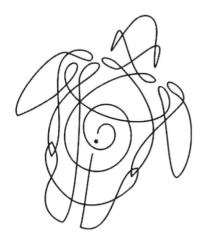

Sea turtle

Sea turtles travel long distances to go back to their birth place. They are symbolic of long voyages and of family. The path of this unalome leads back to the center, indicating family as the beginning and the end of the path to perfection.

Butterfly

Butterflies show us the possibility of change. They start their life crawling the earth as caterpillars.
It may not seem evident, but the transformation will happen.
Give yourself time.

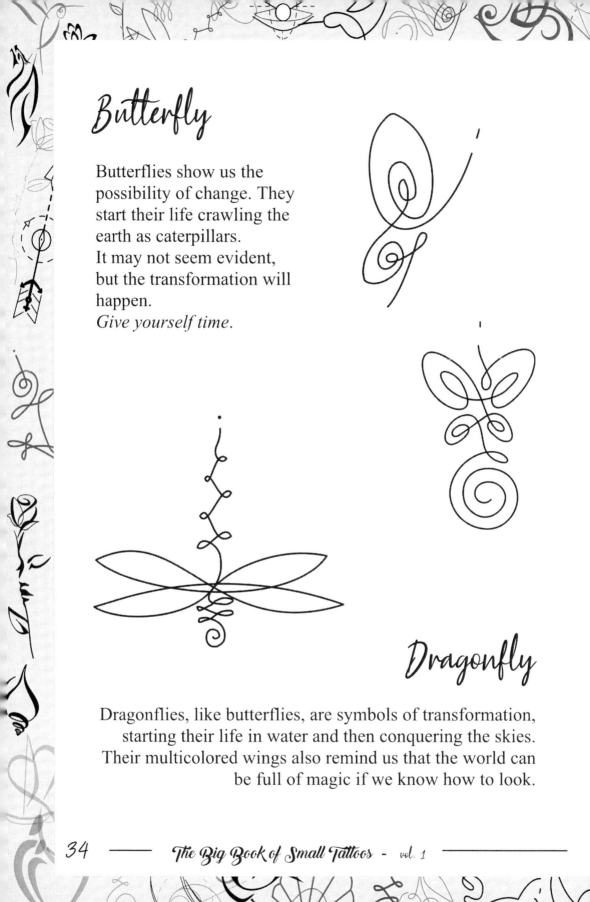

Dragonfly

Dragonflies, like butterflies, are symbols of transformation, starting their life in water and then conquering the skies. Their multicolored wings also remind us that the world can be full of magic if we know how to look.

Swan

The white swan is a symbol of purity and regality.

It represents feminine grace and true love.

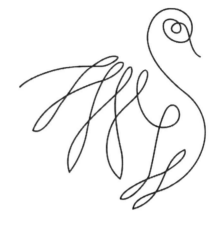

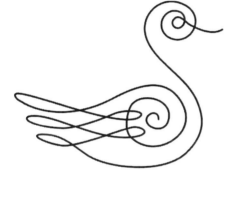

Crane

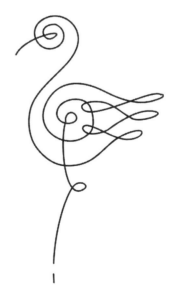

Cranes are a symbol of happiness, health and good luck, social status, and longevity.

Music

There is perfection in music, and we can find our own balance through it, as represented by these treble clef unalomes.

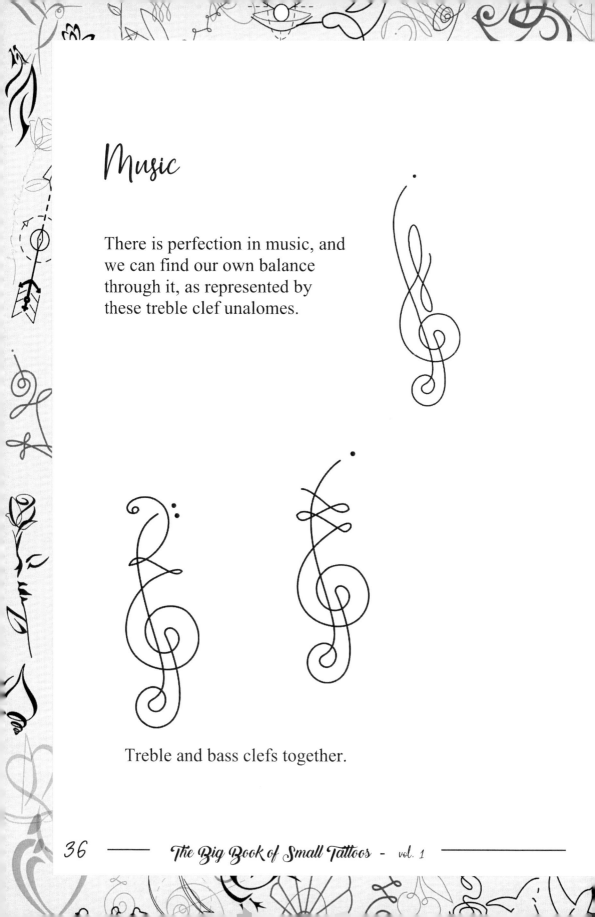

Treble and bass clefs together.

Unalome

Coffee-junkie approved

. . . and sometimes the perfect
moment comes in the shape
of a coffee or tea cup!

Ever felt like
*"Please, don't talk to me until I
had my morning coffee"*?

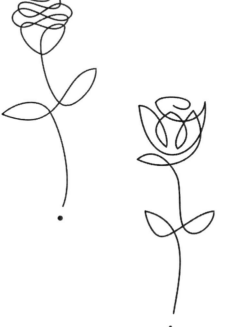

Roses

"But he that dares not
grasp the thorn
should never crave
the rose."

Anne Brontë

Anchor

The anchor is a symbol of stability.

Key

The "key" to perfection . . .

Seashell

. . . is often found
in the small things.

Sunflower

Follow the sun.

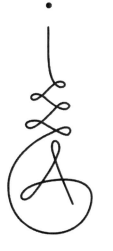

Letters

If someone is a big part of your idea of perfection, the unalome may be shaped to include their initials.

This could mean children, parents, grandparents, and those important figures who shaped or changed how we look at the world. We do suggest though always to avoid a partner's initials: sometimes life unfolds in ways that we can't see beforehand.

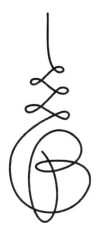

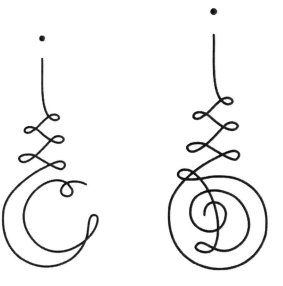

Zodiac signs

Do stars have an influence upon our lives?

Here are five series for the twelve astrological signs: *Aries, Taurus, Gemini, Cancer, Leo, Virgo, Libra, Scorpio, Sagittarius, Capricorn, Aquarius,* and *Pisces.*

Aries

Zodiac signs

Taurus

Gemini

Cancer

Leo

Virgo

Libra

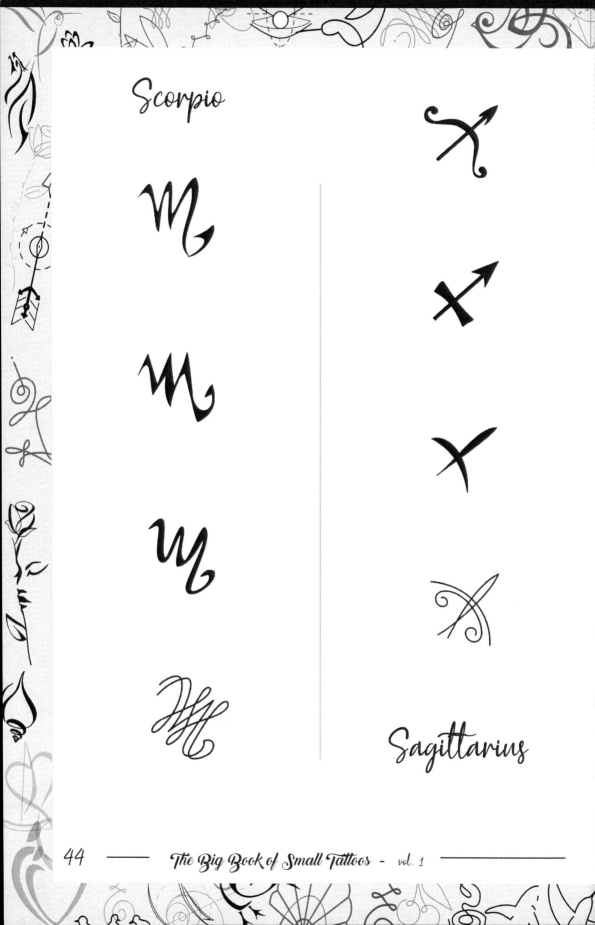

Scorpio

Sagittarius

Capricorn

Aquarius

Pisces

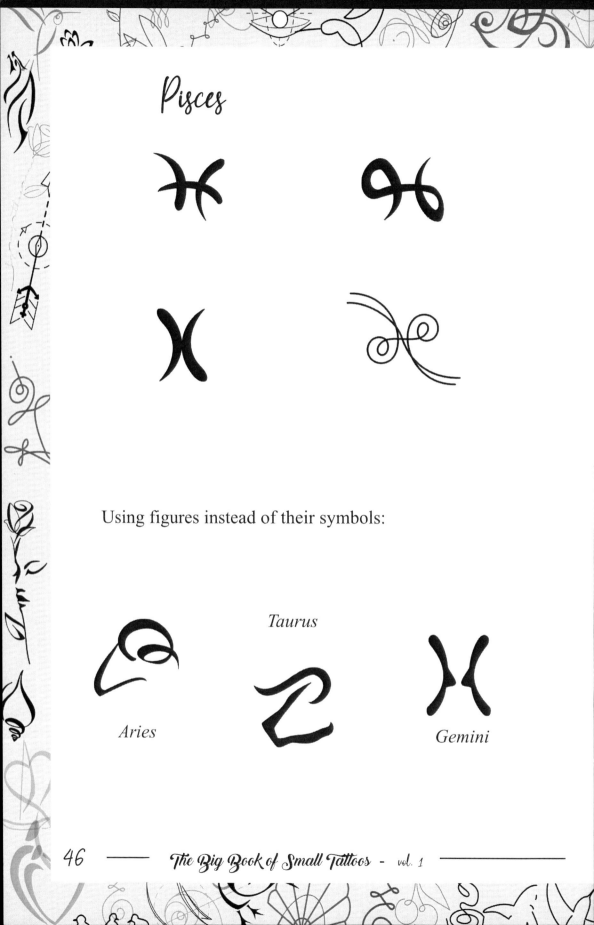

Using figures instead of their symbols:

Aries

Taurus

Gemini

Zodiac signs

Cancer

Leo

Virgo

Scorpio

Libra

Sagittarius

Aquarius

Capricorn

Pisces

Crowns

Crowns are the distinctive sign of kings, queens, and emperors. They traditionally represent royalty, victory, triumph, and glory.
As a tattoo they symbolize being the masters of our own lives.

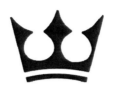

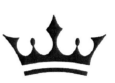

K for King

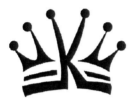

Crowns symbolizing a king and a queen are a nice choice for couples who wish to get matching tattoos without visible initials or names.

For this reason, the crowns in this chapter have been organized in pairs.

Q for Queen

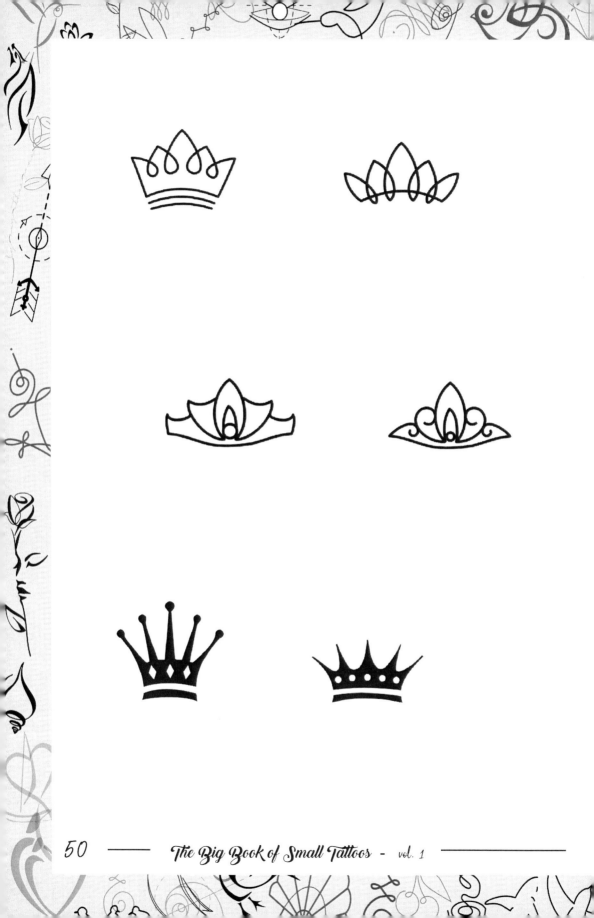

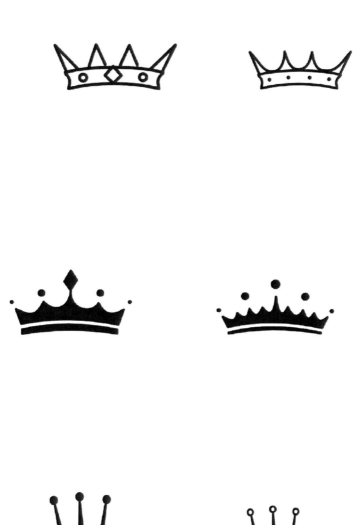

Geometric

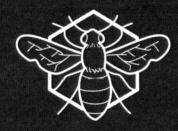

Geometric tattoos are enjoying a renaissance.

But what makes them so appealing?
Possibly the fact that they are often a reflection of the world: they mix straight, sharp elements with round ones, light and bold, strong and delicate.
All the contradictions that life is made of.

The *Seed of Life* is one of the basic shapes of sacred geometry.
It represents the basis for all creation, and it can also be the basis of the creation of various designs like the butterfly below:

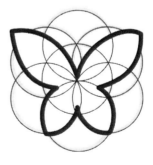

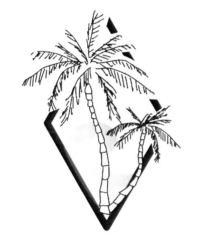

Bold and light lines used together, sharp and round elements, stillness and movement: opposites and their balance are the essence of life.

Time passes and it
becomes shorter.
Carpe diem.

Cherry blossoms also
signify the preciousness
of life.

As we go through life,
we acquire knowledge
and stability.

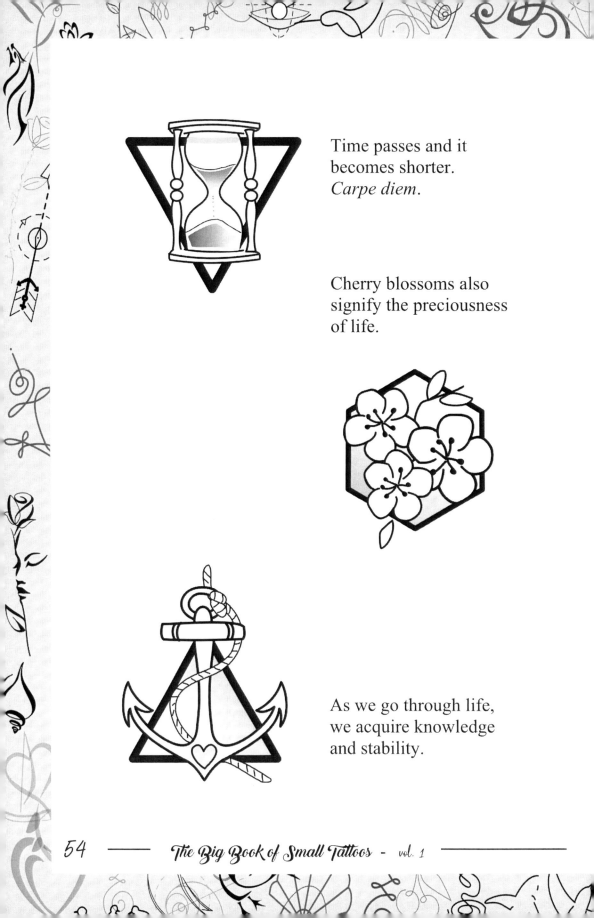

Flowers begin as seeds in the ground, and as they grow they rise above the earth, blooming toward the heavens. Set your aspirations toward the sky!

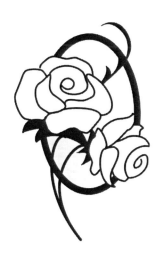

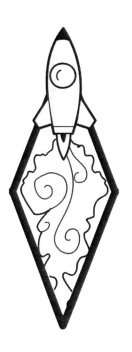

Bees are hardworking,
highly social creatures.

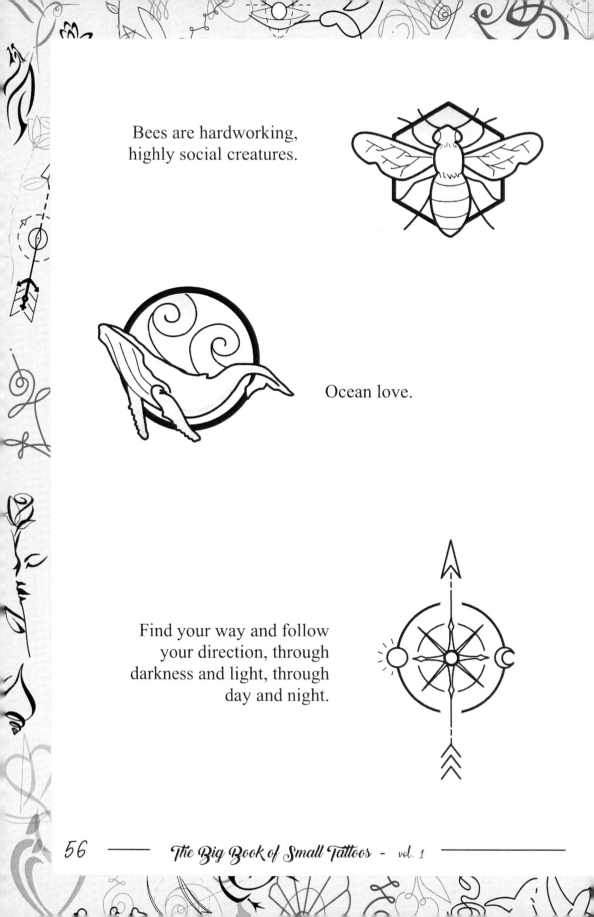

Ocean love.

Find your way and follow
your direction, through
darkness and light, through
day and night.

"Love will guide me."

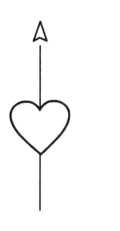

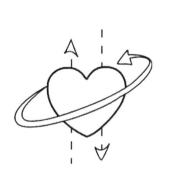

Everything revolves around love. Give, and you will receive.

"Play"

Anchors

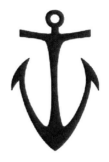

Anchors are symbols of stability. They secure ships through the tempest preventing them from being thrown upon the rocks by the winds and the waves. Similarly, we are like ships in the ocean of life, and we need to find our anchors to have stability, a firm ground.

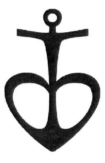

Love is my anchor.

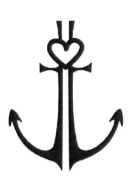

The stability of two people joined together by love.

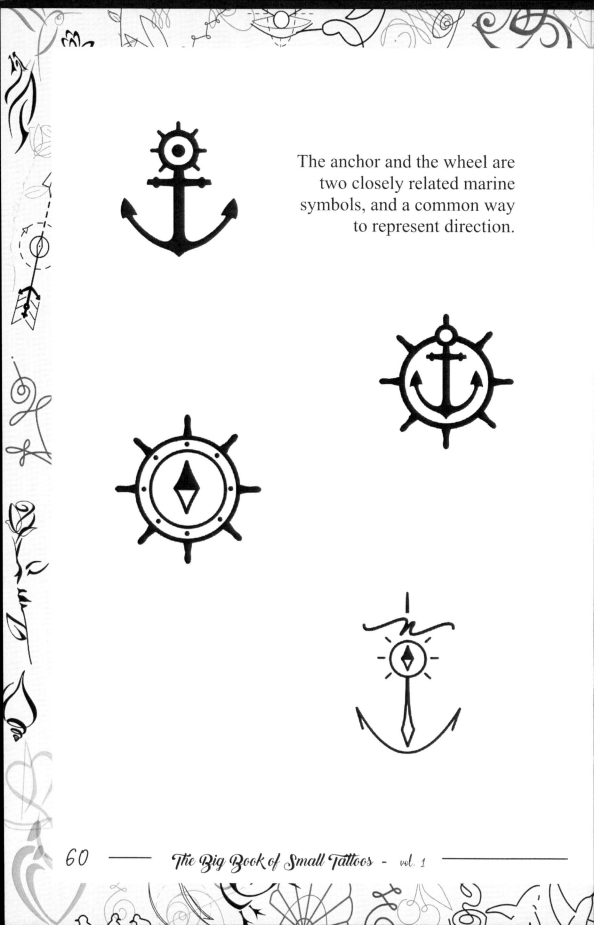

The anchor and the wheel are two closely related marine symbols, and a common way to represent direction.

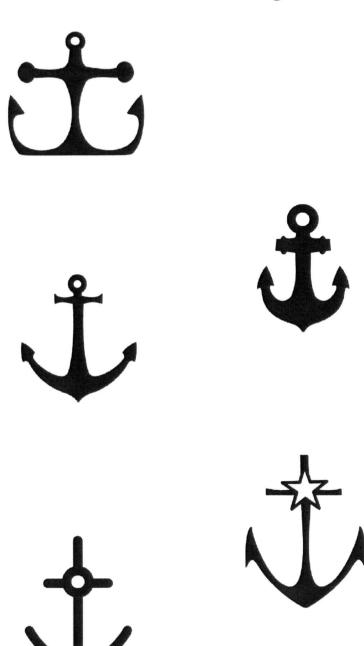

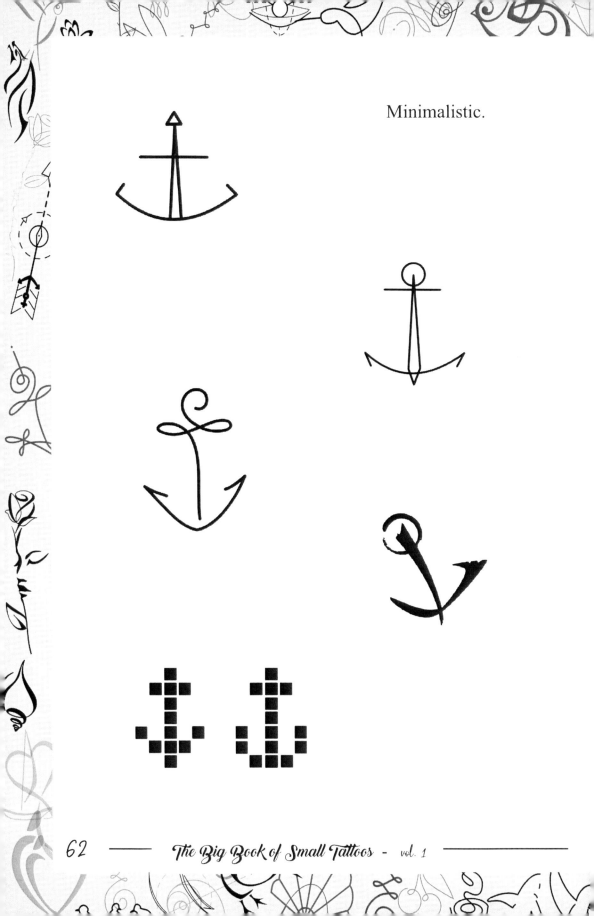

Minimalistic.

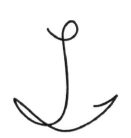

Anchors can be shaped
by words or by letters.

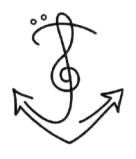

This eye-shaped sun-
moon anchor symbolizes
achieving impossible
things.

Music is my anchor.

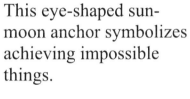

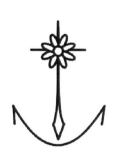

Seashells

There are as many meanings related to seashells as the amount of shapes they can have. They represent protection and prosperity.
Bivalve shells, with their halves strictly bound together, symbolize union and intimacy. They are also a symbol of femininity.

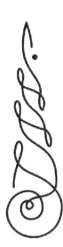

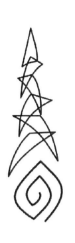

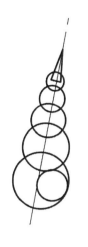

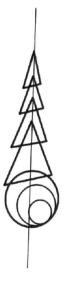

Seashells are a
masterpiece of geometry
and a symbol for steady
and continuous growth.

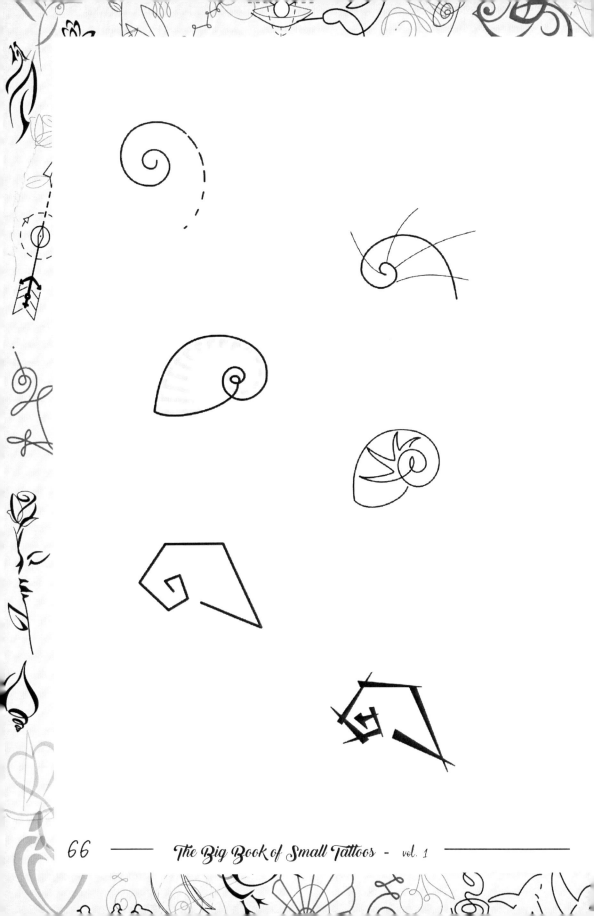

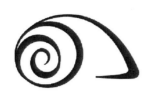

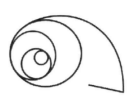

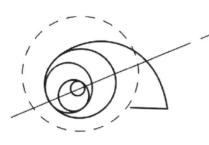

Bivalve shells are a symbol of beauty.
Tridacnas that hide a pearl inside can also symbolize a
hidden secret.

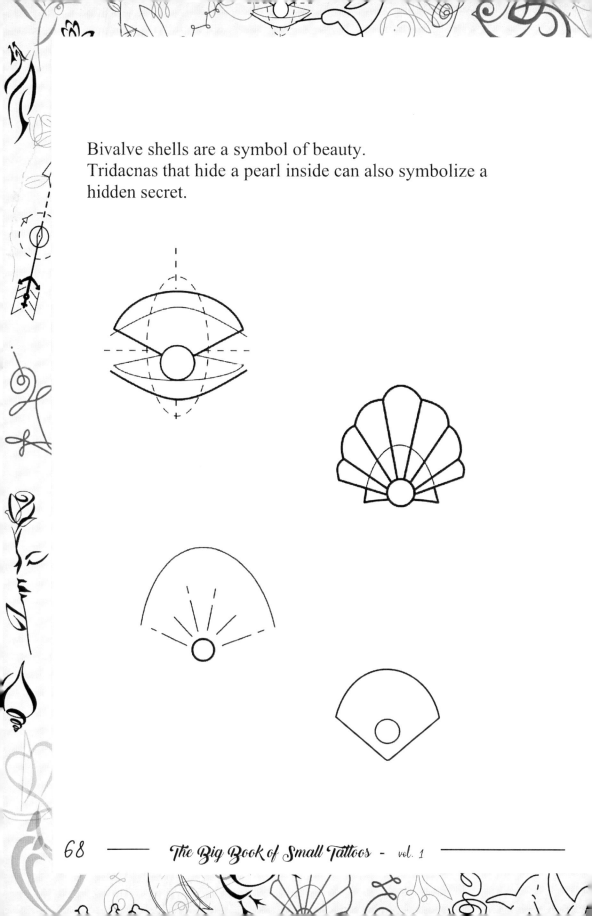

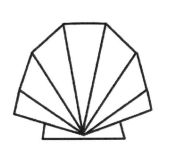

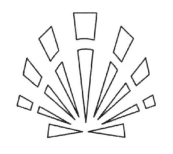

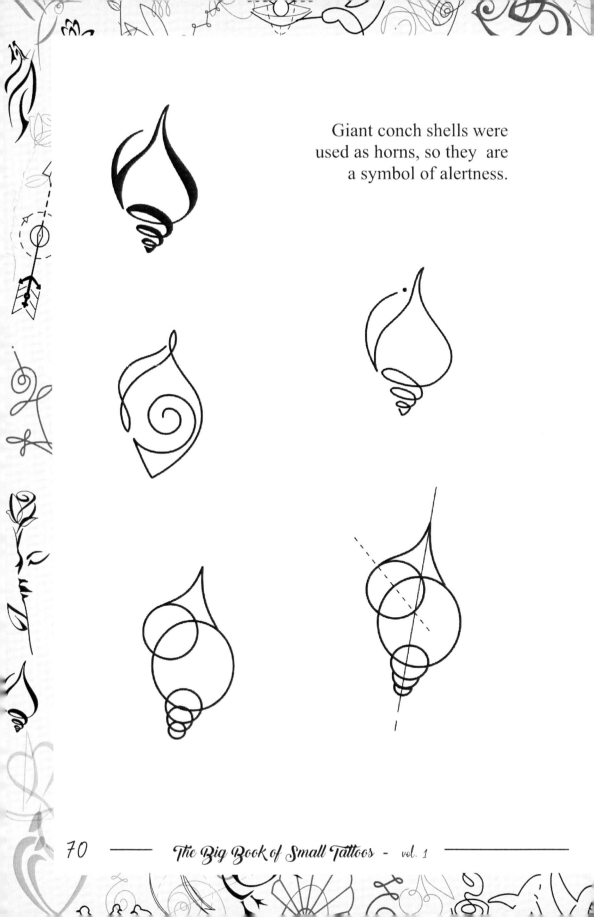

Giant conch shells were
used as horns, so they are
a symbol of alertness.

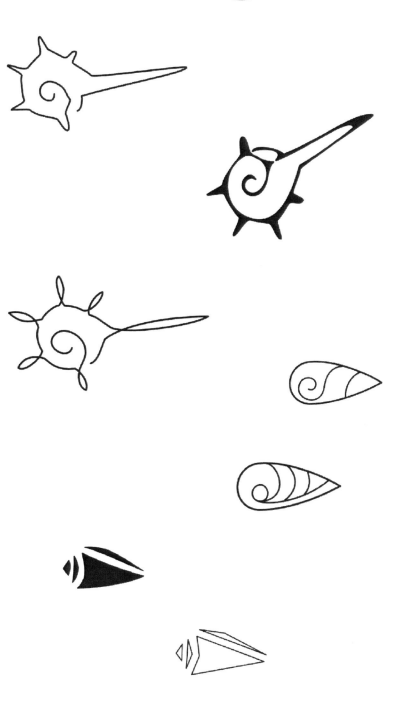

Knives

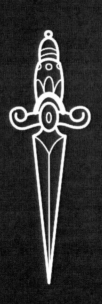

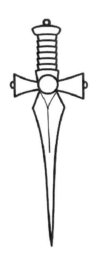

Knives hide many more meanings than it may appear at first.
They are a weapon, which makes them a protection symbol, but they also represent cutting from the past, making a decision, and fighting for it.

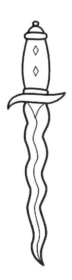

Knives were a very popular element in old school tattoos, favored by sailors for their strong significance and bold look.
Excelling in the use of knives could be life saving in many situations, and the first message such tattoos showed was "Don't mess with me."

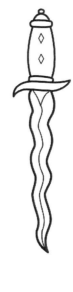

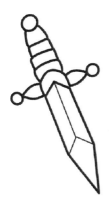

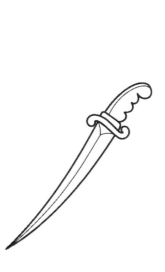

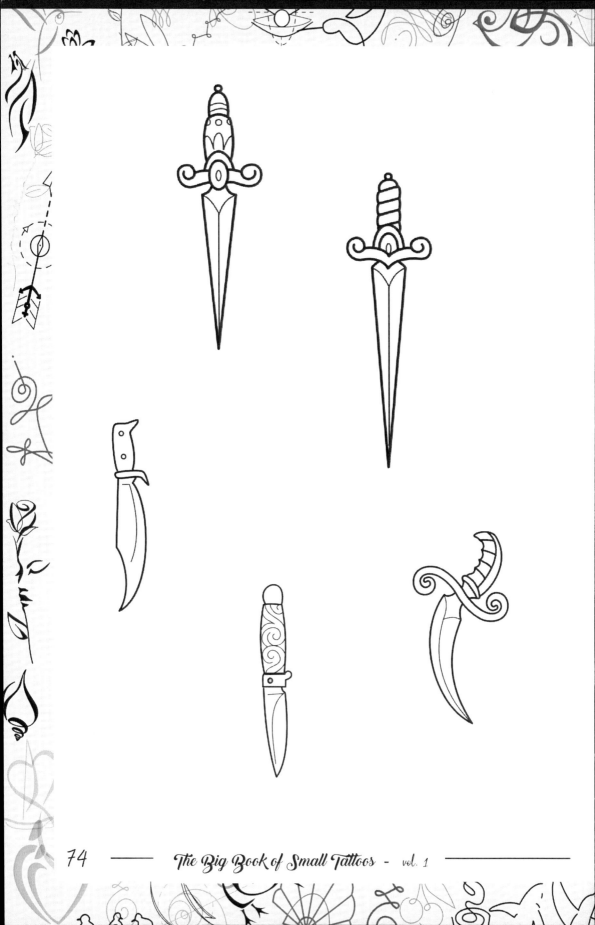

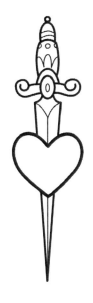

Oftentimes, knives were paired with different symbols, thus inheriting other meanings. A heart in front of a knife, or pierced by it, could symbolize pain for love or a lost love.

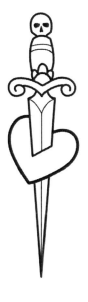

A knife with a heart piercing through a skull was used to symbolize love winning over death.

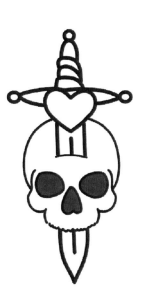

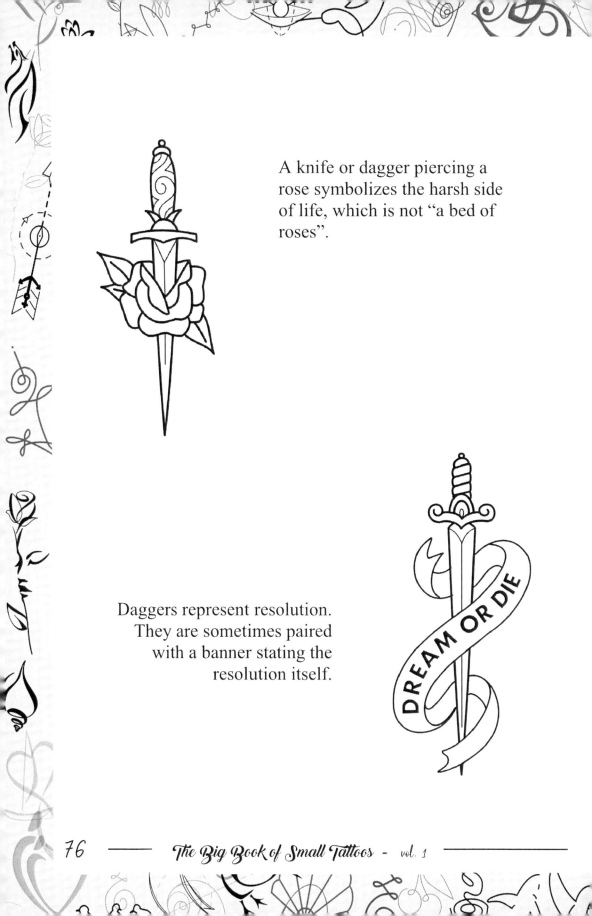

A knife or dagger piercing a rose symbolizes the harsh side of life, which is not "a bed of roses".

Daggers represent resolution. They are sometimes paired with a banner stating the resolution itself.

DREAM OR DIE

Food

The increasing popularity of food tattoos proves how much food has become a focal point in modern society.
When food tattoos become a statement, they are often brightly colored and boldly lined to catch the eye and tell their message loud and clear.

The symbolism of cherries is centered around fertility and desire.
They can also represent love, or a couple, when paired.

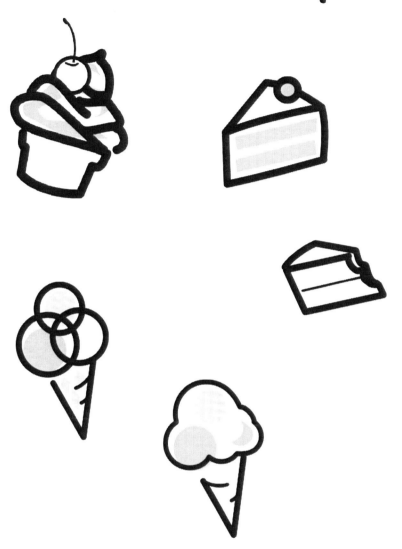

Cherries, ice cream, cakes, and apples, especially if bitten, are common symbols to represent sexuality and passionate love.

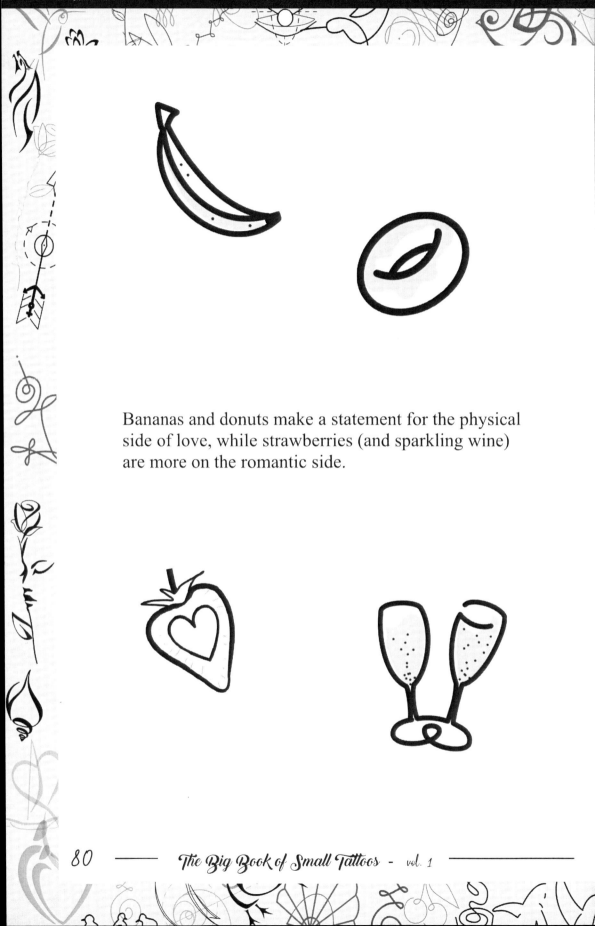

Bananas and donuts make a statement for the physical side of love, while strawberries (and sparkling wine) are more on the romantic side.

"When life gives you lemons . . ."

Too spicy for you?

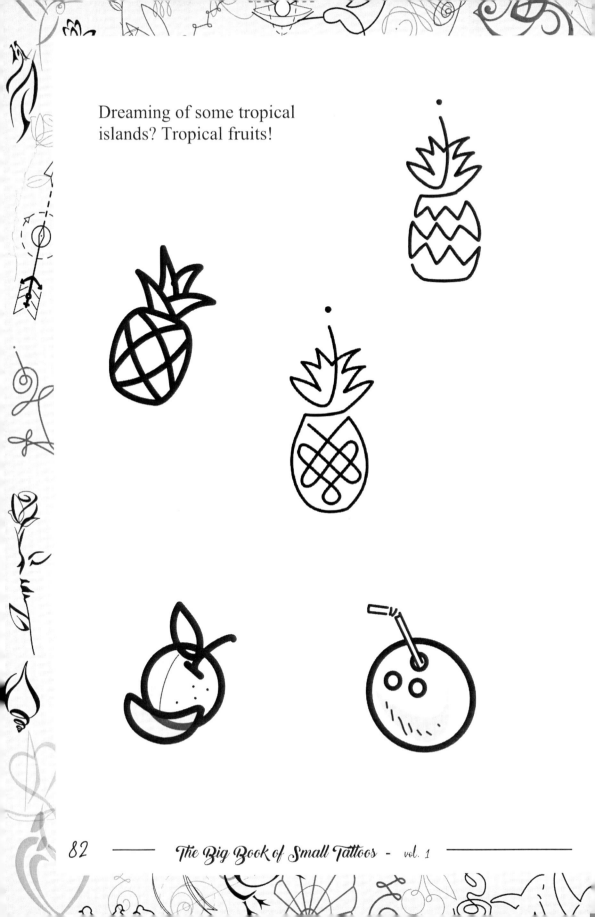

Dreaming of some tropical
islands? Tropical fruits!

Of course, beverages should not be left out.

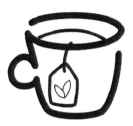

Hi, coffee lover . . . we see you!

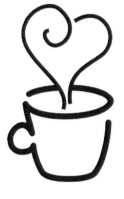

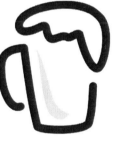

Beer . . . and its favorite companion!

Butterflies

The life of a butterfly
may seem easy for those
who see her flying
effortlessly, free and
colorful.
Yet the butterfly is born
when the caterpillar
"dies".
This symbol tells us of
struggle and rebirth, and
never to give up on our
dreams.

Butterflies have been
compared to flying
flowers for their
colorful beauty.

Lotus and butterfly.
Reborn from adversities.

The road to our perfection is never easy, and sometimes it takes courage, leaving all that we know to embrace our new life and true purpose.

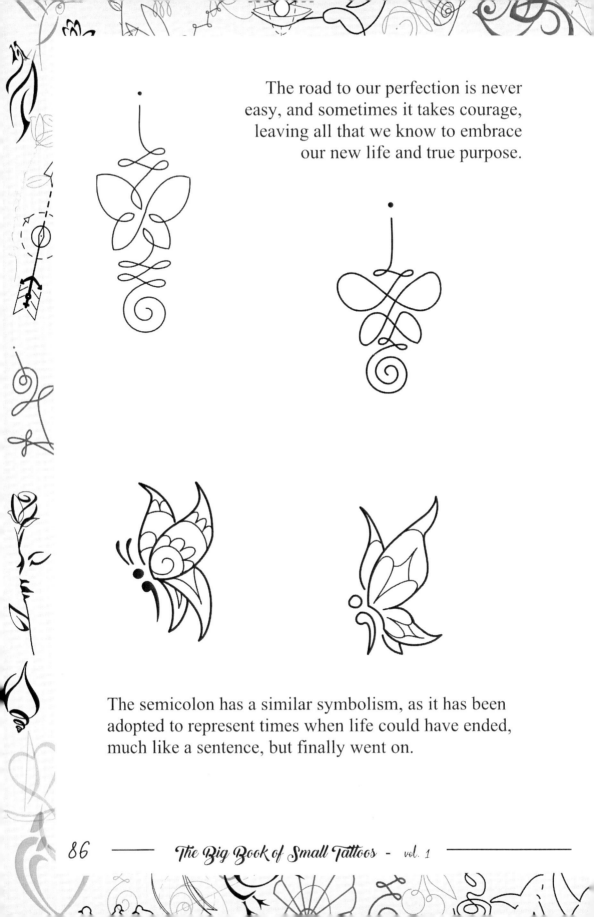

The semicolon has a similar symbolism, as it has been adopted to represent times when life could have ended, much like a sentence, but finally went on.

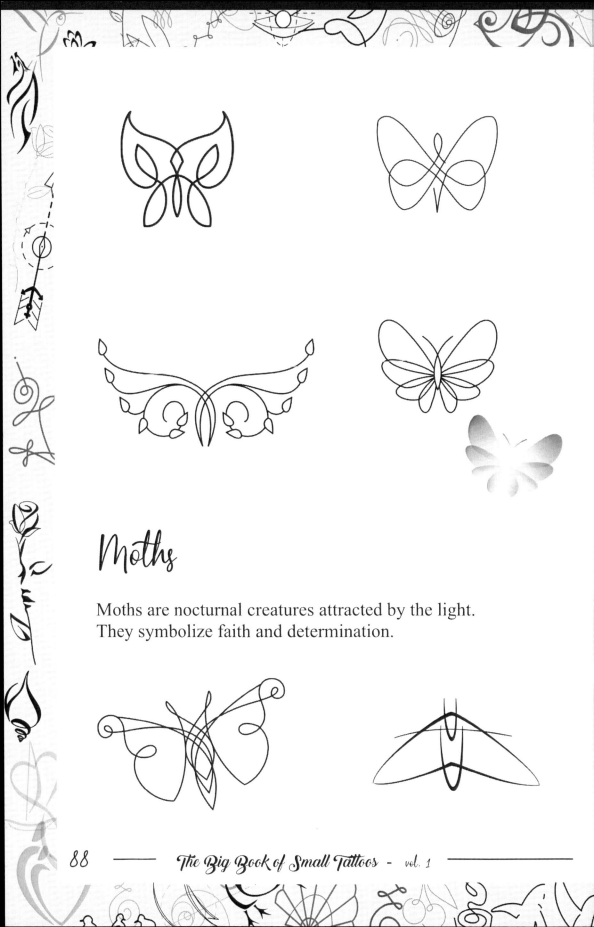

Moths

Moths are nocturnal creatures attracted by the light.
They symbolize faith and determination.

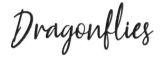

Dragonflies

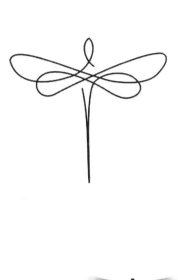

change

Minimalist

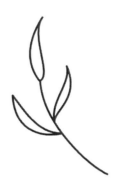

Sometimes less is more.

The idea behind minimalist designs is that if focused on the main traits of an object, a few lines or a single swirling line are enough to portray it and express its essence.

Small plants can represent closeness to nature, and they can be designed in the shape of other elements, like the moon above formed by a cattail.

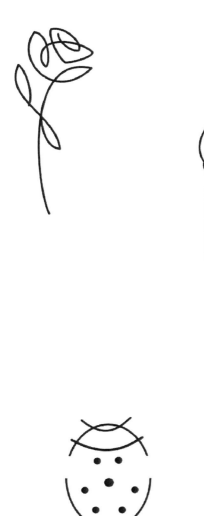

Four-leaf clover and ladybug for good luck.

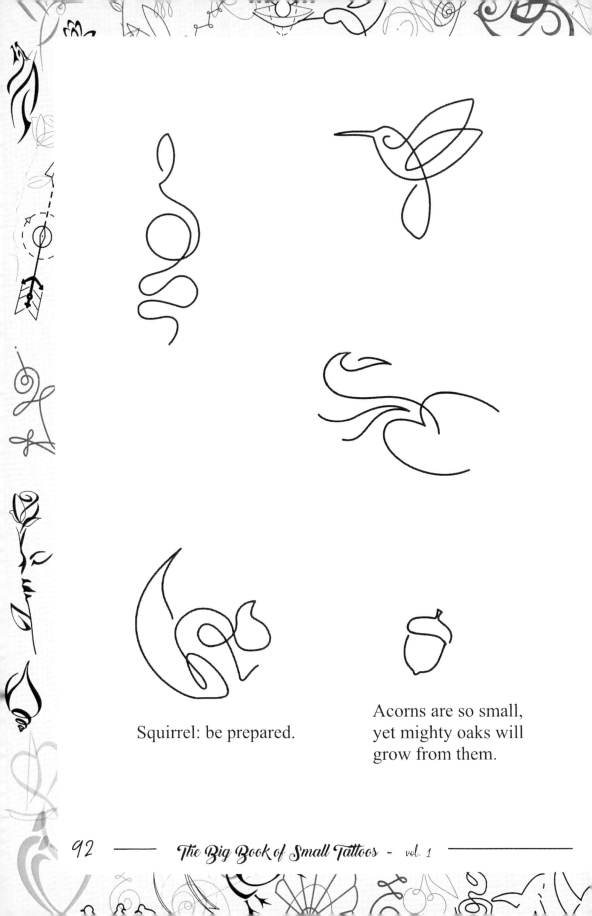

Squirrel: be prepared.

Acorns are so small,
yet mighty oaks will
grow from them.

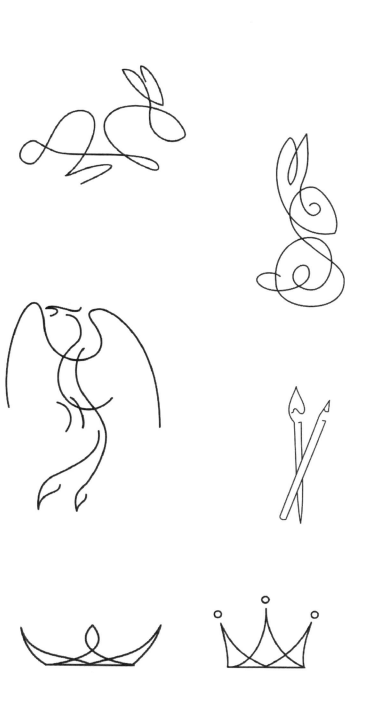

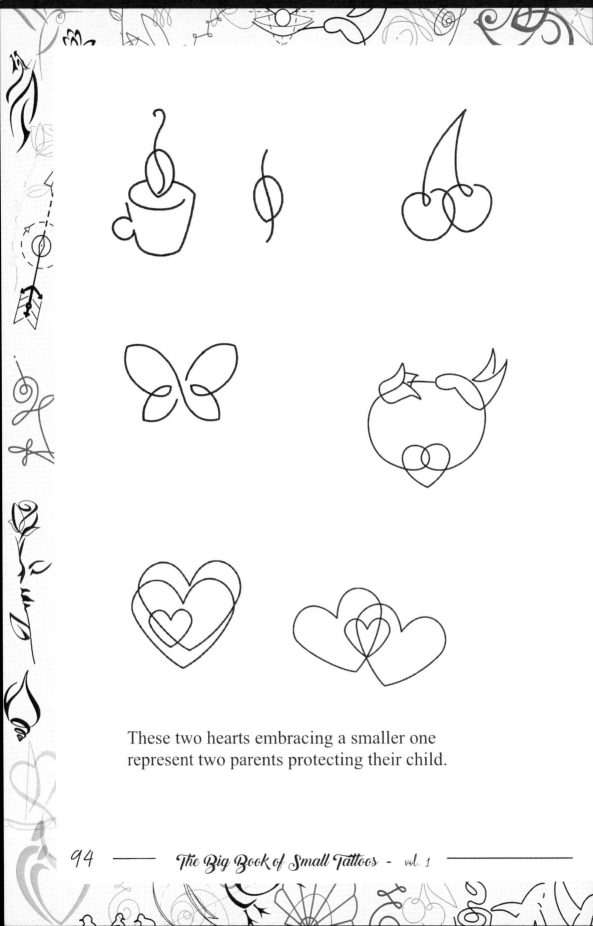

These two hearts embracing a smaller one
represent two parents protecting their child.

Aim for the target.

The sun-moon represents
the impossible that
becomes possible.

Feathers remind us
not to forget some
lightness in life.

After the storm, the sun.

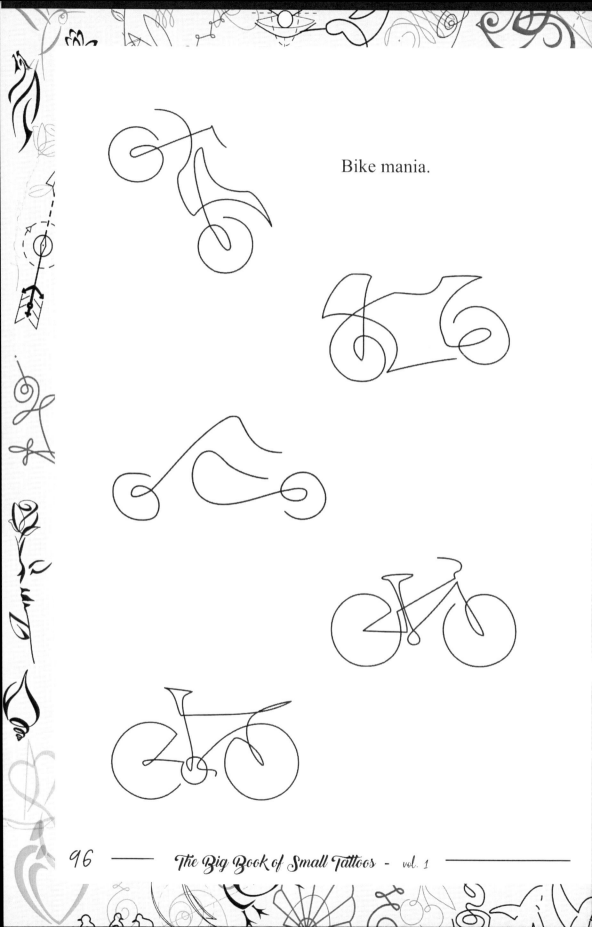

Bike mania.

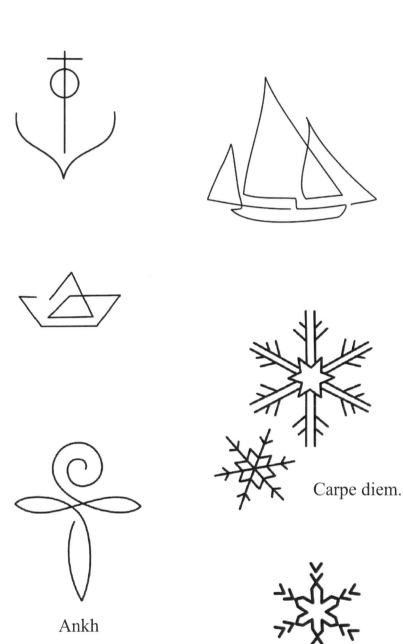

Ankh

Carpe diem.

freedom

Words

freedom

Many cultures around the world share the belief that the world was created by words, sounds modulated in specific ways.
There is truth in this: words can have power, and there are words that have a special meaning to each of us.
Here are some, designed like the object they represent or the concept related to it.

freedom

freedom

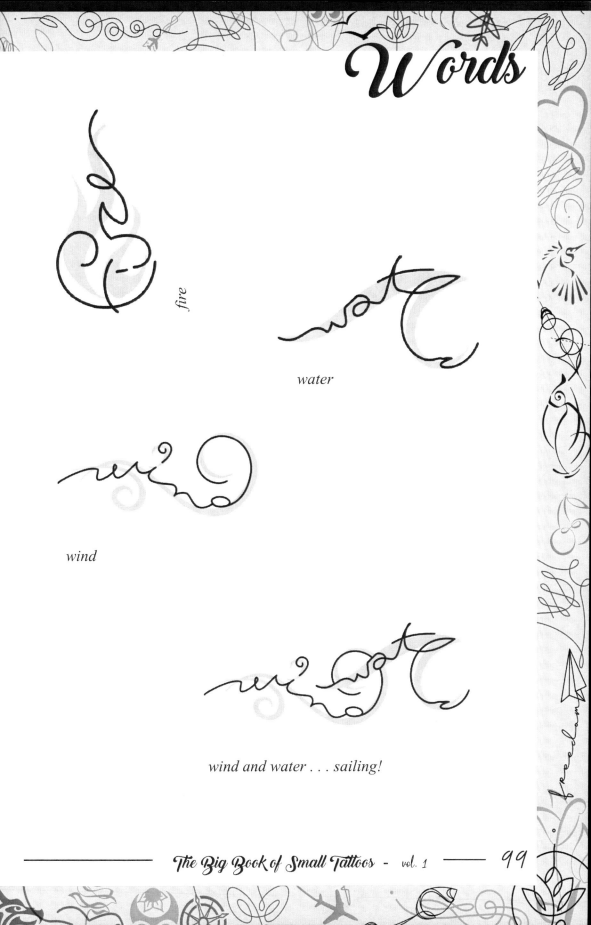

fire

water

wind

wind and water . . . sailing!

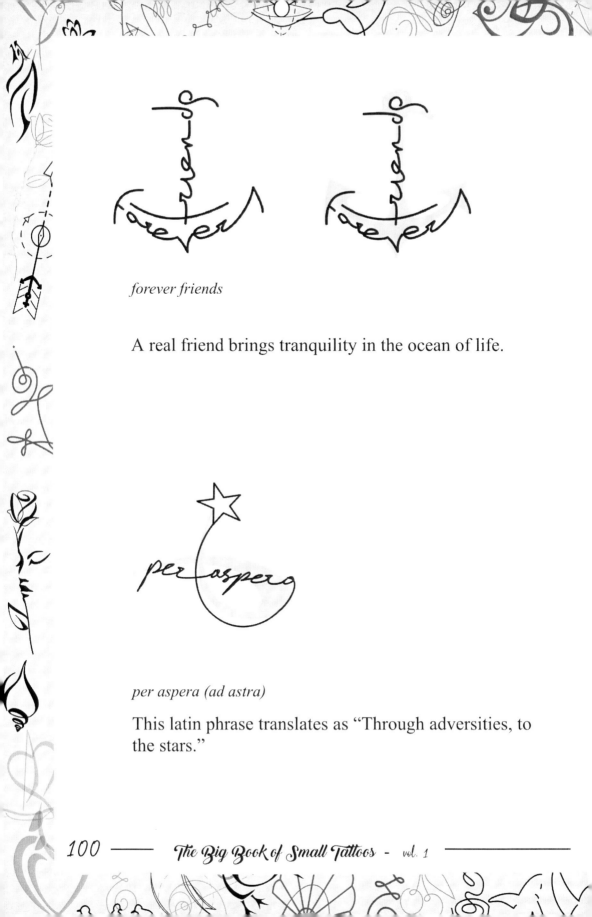

forever friends

A real friend brings tranquility in the ocean of life.

per aspera (ad astra)

This latin phrase translates as "Through adversities, to the stars."

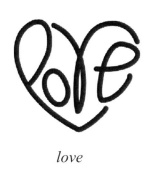

love

family

sisters

Often opposite like day and night, always complementary like being one.

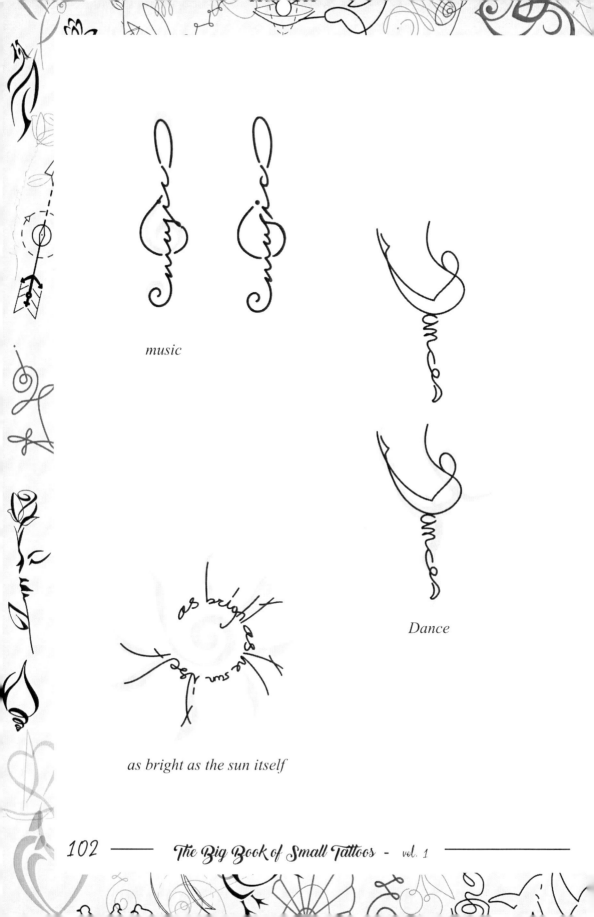

music

Dance

as bright as the sun itself

Dream

wish

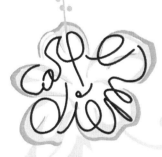

carpe diem

All the designs from this book have never been published before; this is a great opportunity to have a tattoo that's one of a kind.

Each small tattoo can be personalized with just a few minor changes, like adding an element, changing the thickness of its lines, or joining two or more designs together. This chapter will show you some examples of how simple changes can result in unique designs.
Adding colors is another great way to personalize them: most designs in this book are light and with blank areas, and this makes them very easy to be colored. Watercolor style is a perfect match, and it guarantees that there will never be two designs looking the same.

We'll use the roses from the first chapter to illustrate some customization ideas, but of course the same techniques can be applied to any tattoo from this book.

The simplest change consists in thickening some of the lines. It gives more strength and character to a delicate design.

Deciding whether to draw thorns or not can also help emphasize **beauty** and **love** or **strength** and **toughness behind a delicate look**, as in this version where the thorns are created by the word *bloom*.

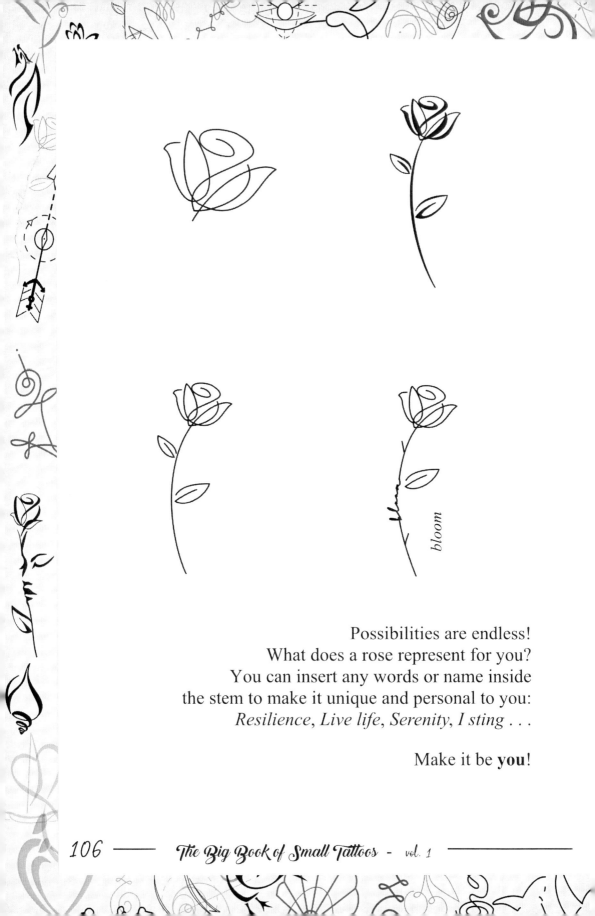

Possibilities are endless!
What does a rose represent for you?
You can insert any words or name inside
the stem to make it unique and personal to you:
Resilience, Live life, Serenity, I sting . . .

Make it be **you!**

More details can be added.
For example, the leaves of the rose could be used to
design a woman's face in order to be a symbol
of beauty and femininity.

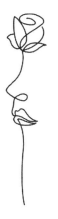

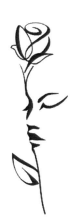

The words in this rose say *by any other name*, referring to a phrase from Shakespeare's *Romeo and Juliet*: "What's in a name? That which we call a rose *by any other name* would smell as sweet." It represents that you are important for the way you are, not for what they call you. **Stay true to yourself**!

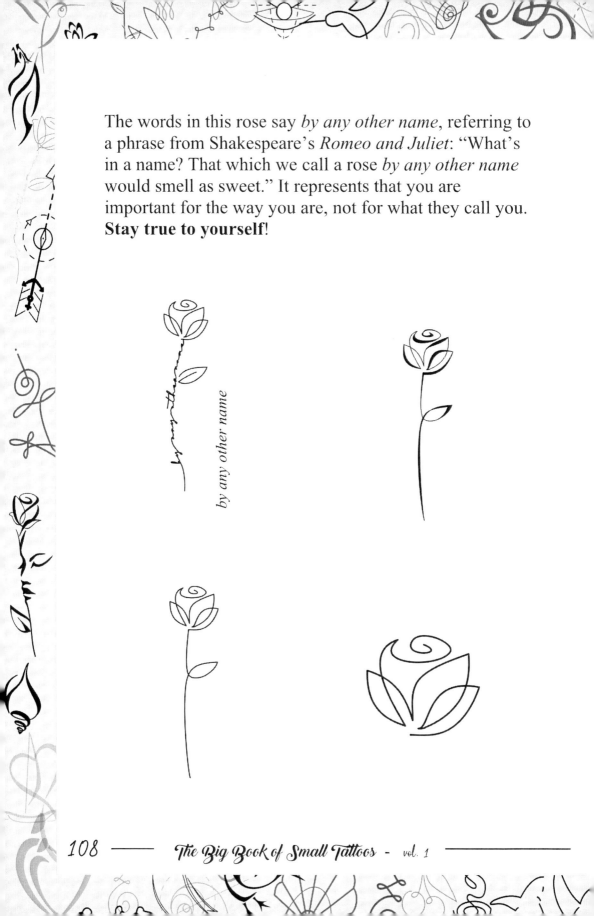

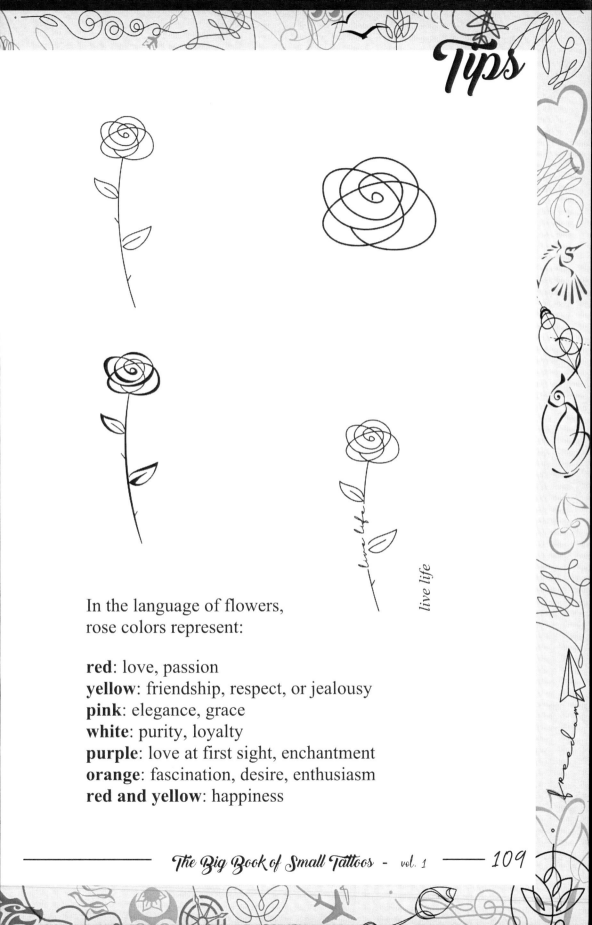

live life

In the language of flowers,
rose colors represent:

red: love, passion
yellow: friendship, respect, or jealousy
pink: elegance, grace
white: purity, loyalty
purple: love at first sight, enchantment
orange: fascination, desire, enthusiasm
red and yellow: happiness

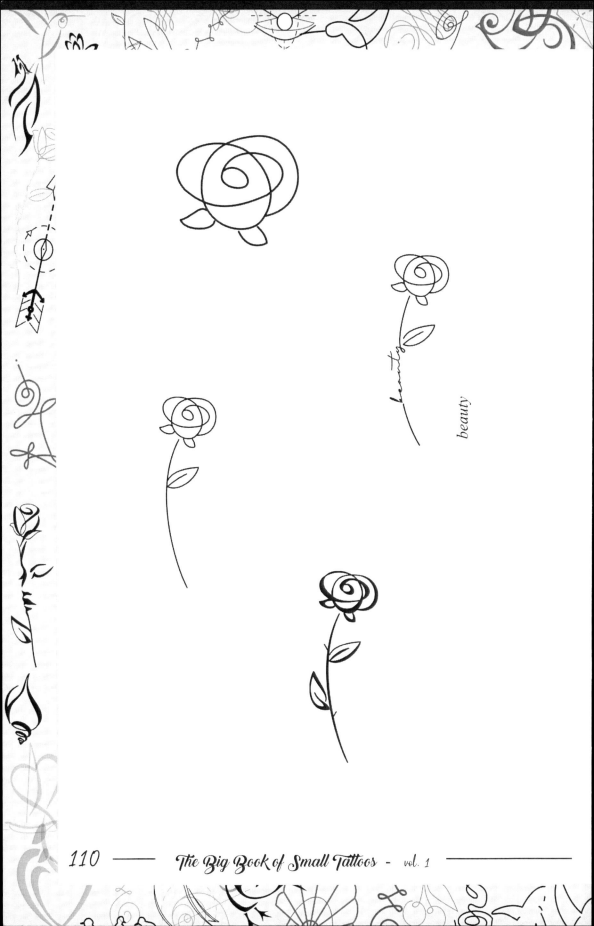

beauty

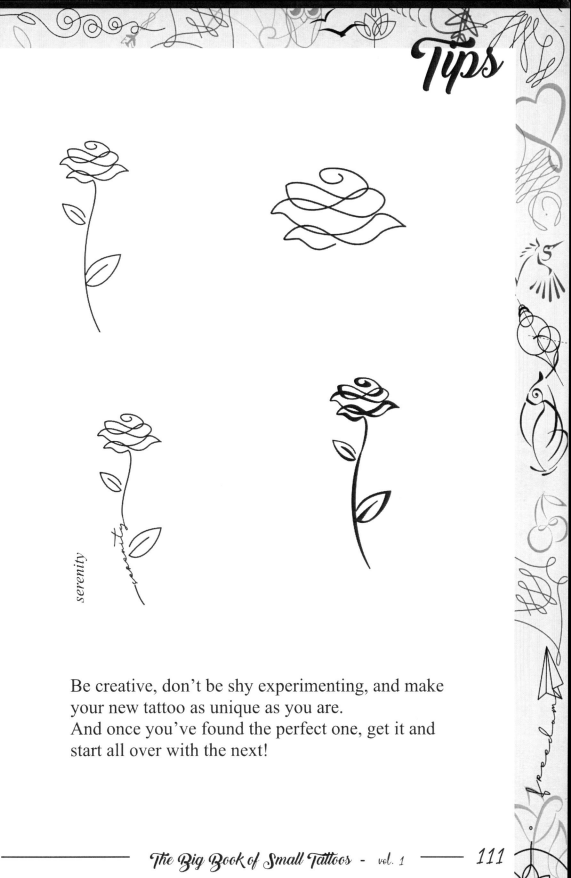

serenity

Be creative, don't be shy experimenting, and make
your new tattoo as unique as you are.
And once you've found the perfect one, get it and
start all over with the next!

All the designs in this bonus section were custom made by TattooTribes for specific persons and therefore should not be used.

They have been included in addition to the 400 original ones in this book to inspire you further and to give you even more ideas for creating your perfect tattoo.

To read their meanings and see more of them, visit www.tattootribes.com

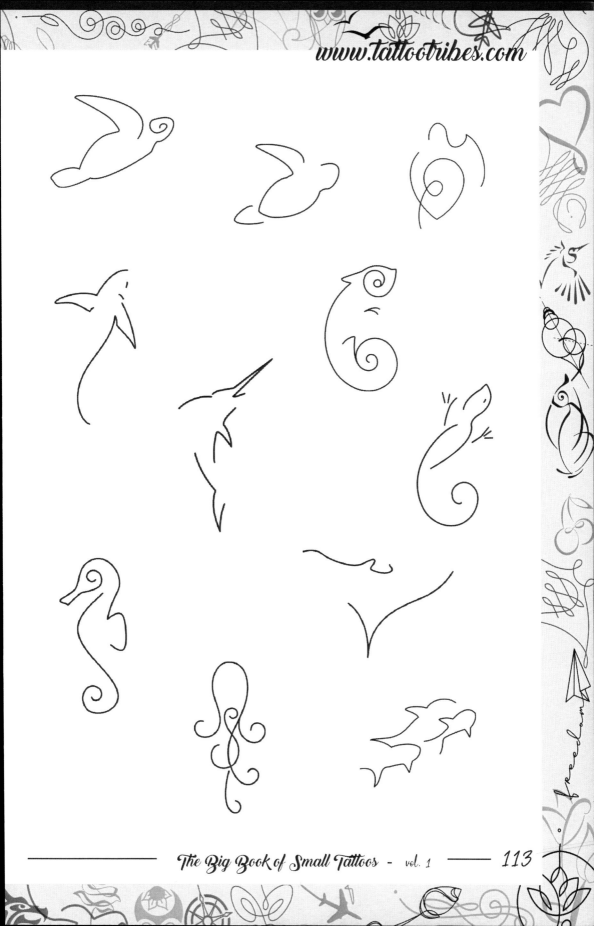

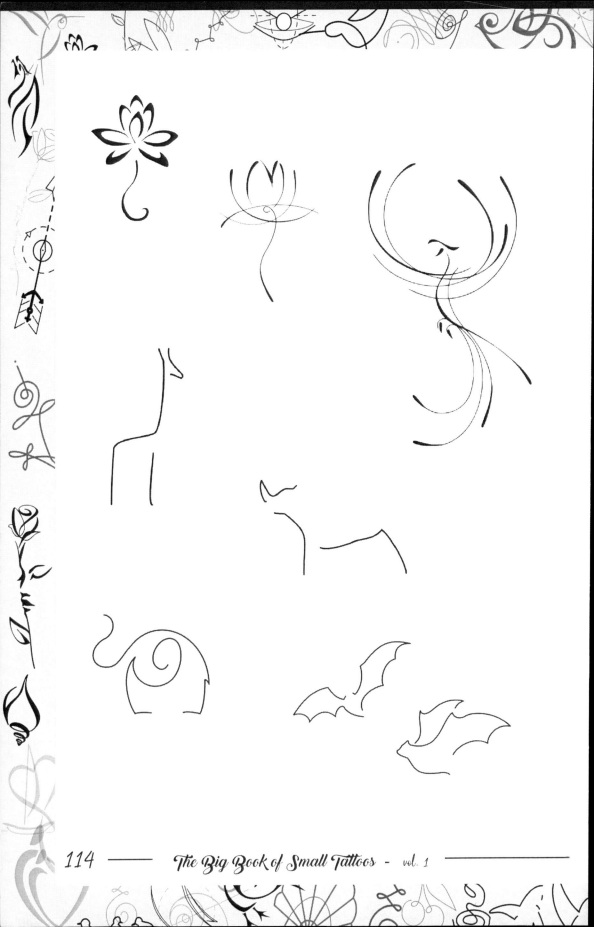

www.tattootribes.com

EXTRA BONUS

Follow the QR code on your phone to suggest
new themes you'd like to see in one of the
upcoming books in this series, and if your
suggestion makes it into a book, you'll get
a FREE copy of it!

https://www.small-tattoo-ideas.com/suggest.html

In the same series:

The Big Book of Small Tattoos - Vol. 0 (2021)
100+ Unalomes & one-line minimalistic tattoos
Can a small tattoo be deeply meaningful? The unalome proves it beyond doubt.
But what are unalomes? What do they represent? Is it right for you to get one? What is the best placement? Find the answers and 100+ designs in this book.

The Big Book of Small Tattoos - Vol. 2 (2021)
200+ small Polynesian tattoos
Each small to minimal design is a statement, embodying an aspect or trait from the Pacific islands, and carrying a memory of palm trees, sun, thriving ocean life and sandy beaches.

More books from TattooTribes:

The Polynesian Tattoo Handbook (2011)
Practical Guide to Creating Meaningful Polynesian Tattoos
Learn Polynesian tattoos and their symbolism. 250+ pages with symbols, their meanings, their placement on the body, case studies, and step-by-step tattoo creation, basic elements, and reusable designs.

Polynesian Tattoo Designs (2014)
Vol.1 - Ocean Legacy
A large-format book collecting all 93 Polynesian-styled tattoo designs from design books numbers 1, 2, 3, and 4, each one accompanied by its stencil: Mantas, Turtles, Sharks, and Sealife.

The Polynesian Tattoo Handbook, Vol. 2 (2018)
An In-Depth Study of Polynesian Tattoos and of Their Foundational Symbols
Unpacking the five main Polynesian styles: Samoan, Marquesan, Tahitian, Hawaiian, and Maori. 206 pages, 550+ illustrations, 400+ symbols and variants.

Polynesian Tattoos (2018)
42 Modern Tribal Designs to Color and Explore
A coloring book for adults featuring 42 original tattoos, each one accompanied by a description of its meanings.

Made in United States
North Haven, CT
17 November 2023

44164558R00067